# Photography for the Joy of It

**Books by Freeman Patterson**
*Photography for the Joy of It*
*Photography and the Art of Seeing*
*Photography of Natural Things*
*Photographing the World Around You*
*Namaqualand: Garden of the Gods*
*Portraits of Earth*
*The Last Wilderness: Images of the Canadian Wild*
*ShadowLight: A Photographer's Life*
*Odysseys: Meditations and Thoughts for a Life's Journey*
*The Garden*

**Book by Nicole Eaton, Hilary Weston and Freeman Patterson**
*In a Canadian Garden*

**Book by Freeman Patterson and André Gallant**
*Photo Impressionism and the Subjective Image*

**Books by André Gallant**
*Photographing People: At Home and Around the World*
*Dreamscapes: Exploring Photo Montages*
*Destinations: A Photographer's Journey*

**Books by André Gallant and Pierre Berton**
*Winter*
*The Great Lakes*
*Seacoasts*

# Photography for the Joy of It

## An Introductory Workshop for Film and Digital Photography

Freeman Patterson and André Gallant

KEY PORTER BOOKS

**Canadian Cataloguing in Publication Data**

Patterson, Freeman
    Photography for the joy of it : an introductory workshop for film and digital photography / Freeman Patterson, author ; André Gallant, co-author.—4th ed.

ISBN 978-1-55263-793-7

1. Photography.  2. Photography—Digital techniques.  I. Gallant, André  II. Title.
TR145.P38 2007      771      C2006-906166-1

The publisher gratefully acknowledges the support of the Canada Council for the Arts and the Ontario Arts Council for its publishing program.

We acknowledge the financial support of the Government of Canada through the Book Publishing Industry Development Program (BPIDP) for our publishing activities.

Key Porter Books Limited
70 The Esplanade
Toronto, Ontario
Canada    M5E 1R2

www.keyporter.com

Electronic formatting: Jean Lightfoot Peters

All photographs are by the authors.

Printed and bound in Canada

07 08 09 10 11 5 4 3 2 1

# Contents

Preface by Freeman Patterson                                      7

Preface by André Gallant                                          9

PHOTOGRAPHY FOR THE JOY OF IT                                    11

CHOOSING YOUR TOOLS
Cameras, lenses, and other equipment                            28
Digital capture                                                  43
Film and film cameras                                            51

LEARNING TO SEE
Discipline                                                       58
Properties of light                                              60
Directions of light                                              62
Exposure                                                         79
Symbols and design                                               83
Point of focus and depth of field                              101

MAKING PICTURES
The importance of using your camera                             106
Experimenting with selective focus                              108
Showing motion in still pictures                                111
Using flash                                                     116
Creating double and multiple exposures                         119
Making pictures at night                                        121
Photographing children and other people                        137
Forty tips and suggestions                                      155

About Freeman Patterson                                         161
About André Gallant                                             163

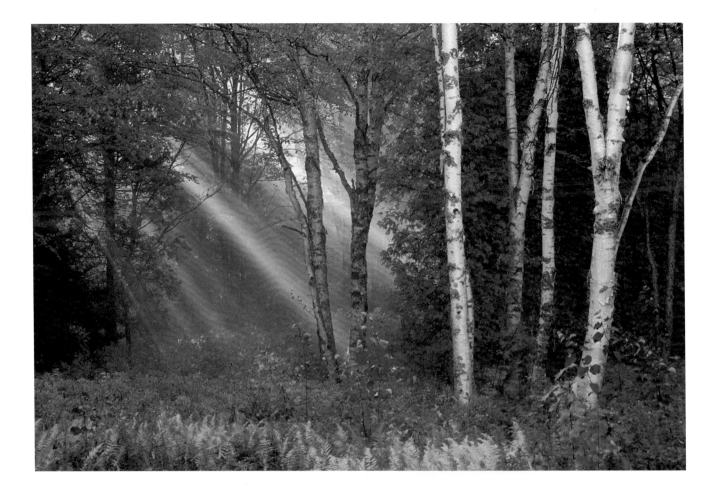

# Preface by Freeman Patterson

For me the joy of photography lies in being at ease with my camera, being keenly aware of things around me, and feeling free to photograph them as I please. It's not in being restricted by rules or formulas, by equipment or technical considerations, by subject matter or other photographers and their work. It's in being myself and in making photographs that communicate what I see and what I feel about what I see. It's also in being disciplined—being thoughtful about what I do so that I capture the images I want. After more than forty years as an amateur and professional photographer, I am even more convinced that fine images don't happen, they are made—and made very carefully. Using my camera regularly and analysing what I am doing and why has made photography a deeply satisfying, creative adventure.

However, this book is for *you*—whether you have only a basic knowledge of camera operation or have been making fine images for many years. It's about learning to "see"—learning to be aware of things around you, seeing things you have never noticed before, using your eyes all the time, not just when you pick up your camera. It's about being conscious of your subject matter and your treatment of it—and what it means to you and those who view your pictures of it. It's also about improving your ability to make the pictures you want. Although the technical references are to both digital and 35mm single-lens reflex cameras, the book is also for photographers who own other camera systems. It's for the colour photographer and the black-and-white photographer, the photographer of nature, of architecture, of people young and old, and of situations near at hand or far away from where you live. It's for everyone who wants to photograph—for the joy of it!

I am grateful to the thousands of readers and workshop students who, during the years since 1977, have communicated their positive responses to the original and subsequent editions of *Photography for the Joy of It*. Readers of this edition, the fourth, will benefit from their experience and input. Also, I want to express very special appreciation to my first editor, Susan Kiil, who worked with me on the original edition and guided me through the creation of several books that followed.

Most of all, I am delighted to have André Gallant, my workshop teaching partner of many years, join me as co-author of this latest edition. His sensitivity to photographers' concerns and his expertise in the medium enrich the text tremendously. Although for the most part we have blended our respective writing as seamlessly as possible, here and there we describe or reflect on our own personal experiences. We hope you will find that our co-operative effort helps you to make better photographs.

*Freeman Patterson*
*Shamper's Bluff*
*New Brunswick*
*January 2007*

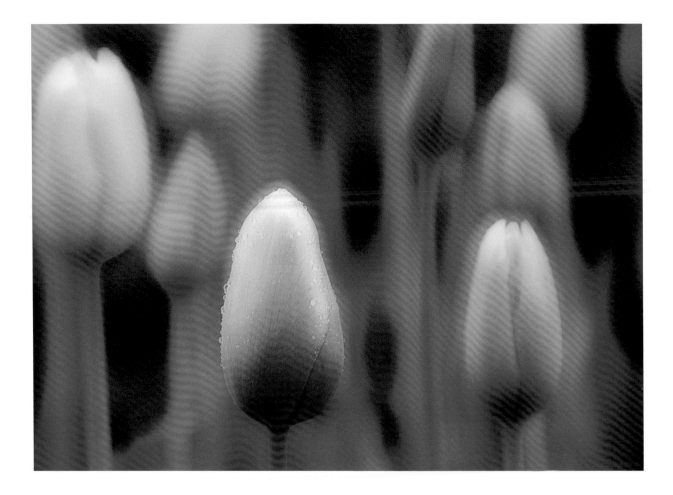

# Preface by André Gallant

In the late eighties I made photography my career, and this passion of mine always brings joy into my life. It has taught me to appreciate what surrounds me, making me aware of the beautiful, but also the not so beautiful. Looking through my camera, I've seen majestic landscapes all over the world and observed vanishing cultures resisting change and clinging to ancient rituals. In the birth of a child and the cremation of a Hindu, I've observed rituals of life and death. Because of photography, I've witnessed phenomenal occurrences, like the migration of monarch butterflies in Mexico, the calving of a glacier on the Greenland coast, and a whale hunt in Nunavut. I've made friends with the people I've photographed, and the people I photograph with. Picture-making is my best teacher. It also fulfills my need to be creative, which in turn contributes tremendously to my happiness. Standing behind a camera is a part of me, as is sharing my images and teaching. Photographs are about equipment, light, and your subject, but it's also about emotions, experiences, and living.

There have been a lot of changes in photography since *Photography for the Joy of It* was first published, especially in the past few years with the advent of digital imaging. Thanks to Mark Belliveau for helping out with the digital sections and for proofreading the book.

Having stood behind a camera for more than twenty years, I want to share with you what I've learned as a photographer, both technically and aesthetically. My wish is that you get as much joy out of your photography as I do.

When Freeman asked if I would co-author this revised edition, I was moved and felt honoured to be a part of this project. I remember reading the book when it originally came out, and looking at the photographs over and over again. I never thought that years later I would help revise one of my most cherished photography books. This really is the joy of photography.

*André Gallant*
*Saint John*
*New Brunswick*
*January 2007*

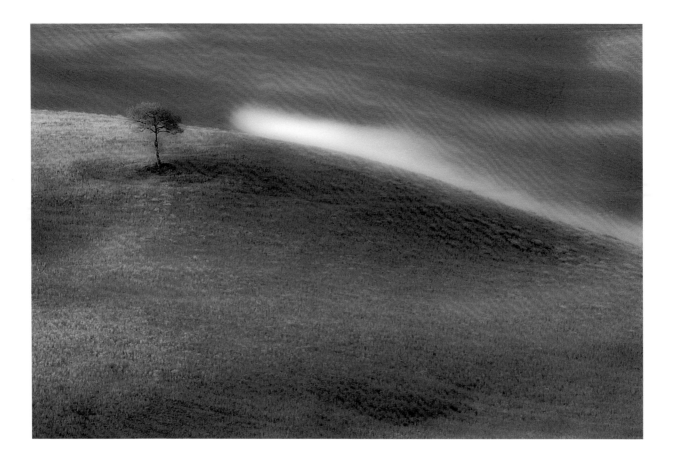

# PHOTOGRAPHY
# FOR THE JOY OF IT

In many situations, of course, you won't have time for reflection. You'll have to act—fast! But afterward, when you see your images, ask the same questions. Picture evaluation is much more than deciding whether or not you used the right lens or exposure; it's deciding if the image you made accurately represents how you felt at the time you made it. Useful evaluation means looking at yourself as well as at your photographs.

Making photographs aids the process of self-discovery. Studying your images helps it further. A happy sort of spiral commences, and continues as long as you make pictures regularly. The more images you make thoughtfully, the better you know yourself; the better you know yourself, the more likely you are to make pictures that satisfy you.

It's very important to *be yourself* when you are making photographs. Try to learn from others without letting them direct your interests or cloud your personal vision. A good teacher will not try to force you in any particular direction, and a good student will not follow even the best instructor like a sheep. Plot your own directions and follow them. Whether you are documenting subjects that are important to you, or using them as vehicles to express your own ideas and feelings, do your photography *for the joy of it*! There's no better reason for making pictures.

For everybody, photography is an opportunity to discover personal paths and to follow those that promise excitement and pleasure. You can wander at your own pace, pause to appreciate each new discovery, and move on at will. Photography is a way to explore your world and yourself. You may answer the call of your own spirit. You are free. If you learn to see well and to use your tools effectively, your photographs will be unique personal expressions, images that bring you joy in the making—and in the sharing with other people.

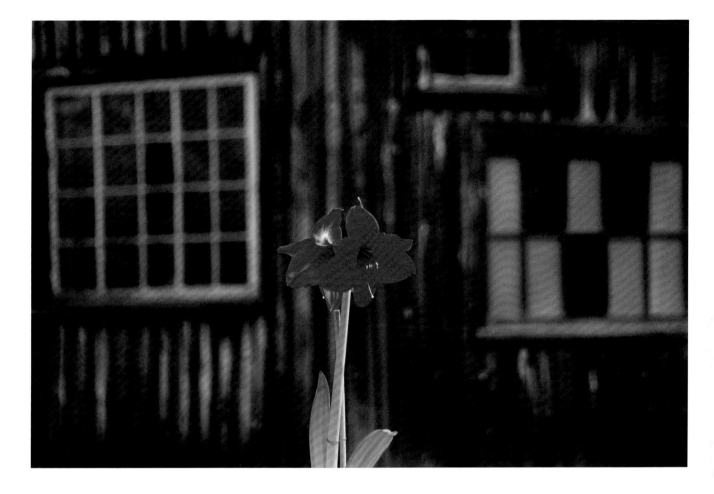

This composition depends on some bold visual features. The flower stands out strongly because it is red, because it is placed almost exactly in the centre of the picture space (seldom a good choice), and because the background lacks any competing brightness of tone or hue and is deliberately rendered somewhat out-of-focus. Also, I took great care to make sure that the blossom did not merge with any of the barn windows. (*FP*)

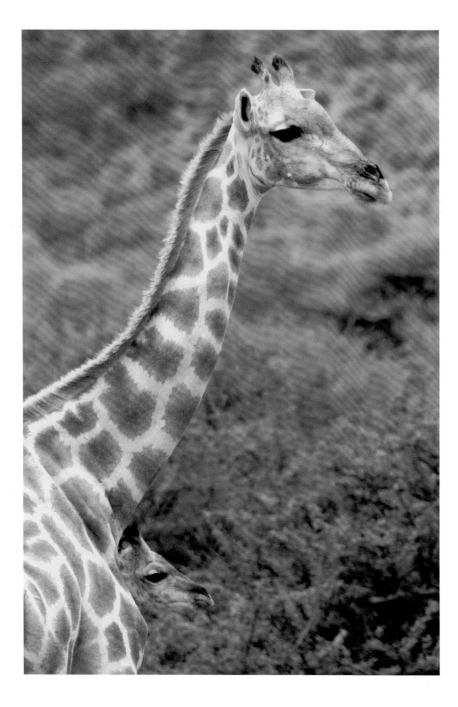

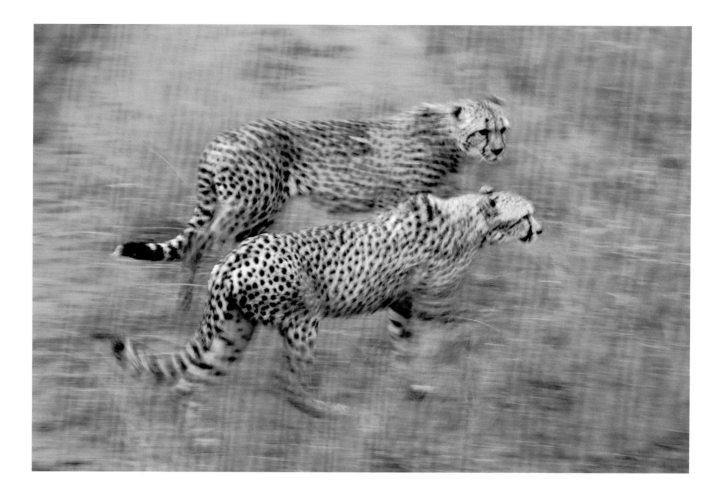

Travelling to Namibia with friends, I stayed at Okonjima, a game farm and home of the AfriCat Foundation. We made several outings, looking for wildlife, and were lucky enough to come across some giraffes and cheetahs. Using my digital camera, I took many photos. It was helpful to see the images on the LCD screen, especially when panning these moving felines.

For the photograph of the giraffes, I decided to use Photoshop to convert the colour digital file to black-and-white. Then I added a sepia hue to the image. (AG)

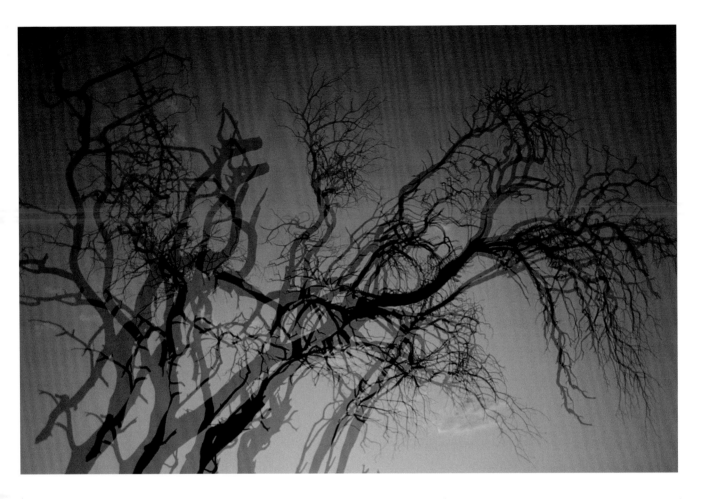

This is a double exposure made at sunset. After the first expo-sure, I shifted the camera position slightly. In the second composition the tree overlapped itself only in certain places. These show up in the picture as black. Where sky overlapped the tree in the second composition, the result is a grey tone in the trunk and branches. I find this skeleton spookier than a straight shot of the tree that I made at the same time. (FP)

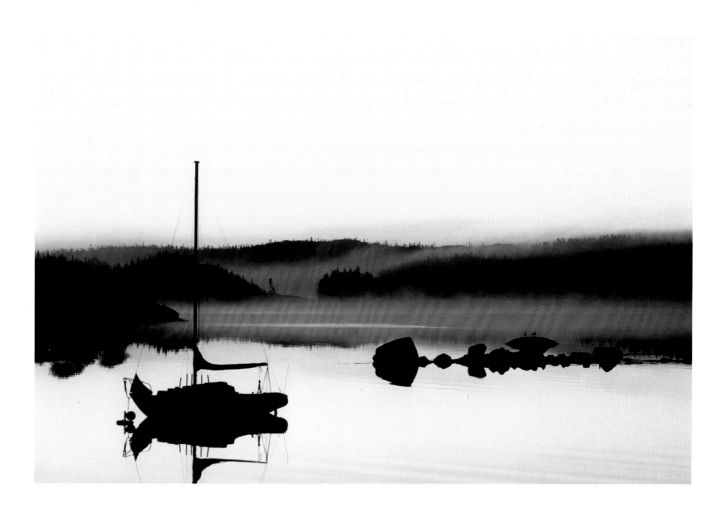

Quite a few years ago, I was staying with friends in Dartmouth, Nova Scotia. Every day, I would listen to the weather forecast, and when it predicted a clear night and a sunny day, I would get up early and head to Peggy's Cove for sunrise. I remember leaving at 4:30 a.m., under a starry sky, and driving toward my destination. When I saw this scene in West Dover, I had to stop and photograph it. To capture the lightness in the sky and the reflection, I overexposed my transparency film, bracketing between one and one-and-a-half stops. The results were what I'd hoped for. (AG)

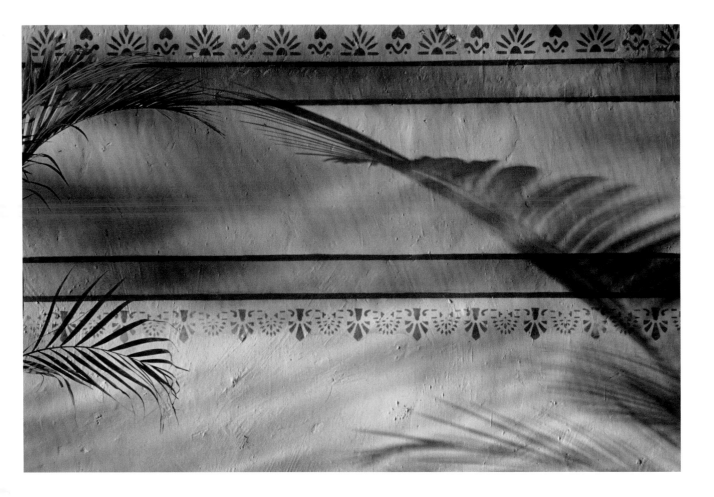

On a trip to the Yucatan Peninsula in Mexico, I was fortunate to stay at an old hacienda that has been converted into a boutique hotel. One of the potted plants on the long porch cast its shadow on the beautifully painted wall. I ran to my room to get my camera and tripod. Sometimes you find beauty in the simplest things. (AG)

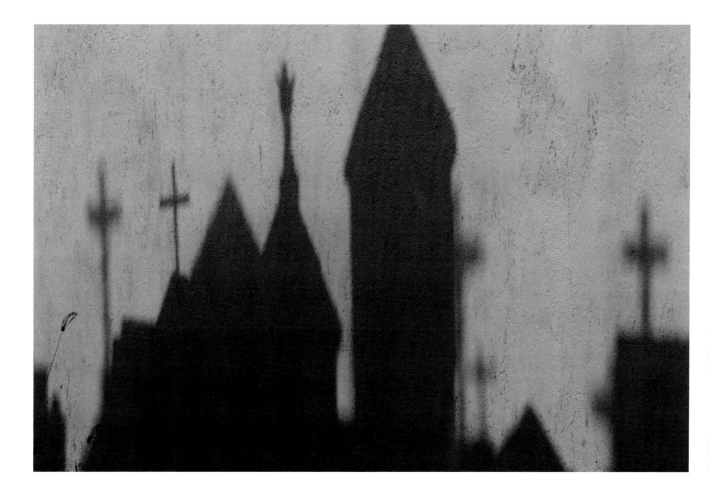

The cemeteries in Mexico are very colourful, and they are also crowded. When I reached the graveyard in Ticul, the sun was nearing the horizon and I knew I had only fifteen to twenty minutes left until sunset. Feeling rushed, I could not settle on anything to photograph, and all my compositions appeared cluttered. Then I noticed the wall surrounding the cemetery, and the shadows of tombstones and crosses that appeared across it. This is my favourite image made that day. (AG)

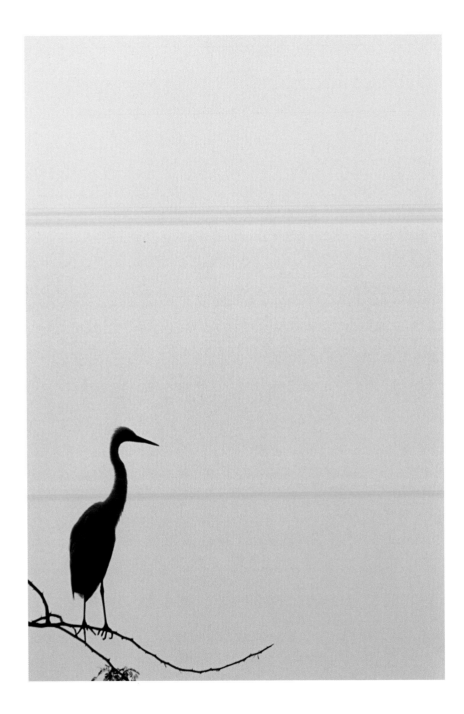

While walking in the bird sanctuary at Bahratpu, in Rhajasthan, India, I looked up and saw this heron, poised elegantly on a small branch. Trying not to startle the bird, I reached cautiously for my camera and tripod. In composing the photograph, I included lots of space around the bird. I exposed for the bright sky (overexposing transparency film by one stop) to paint a silhouette of the heron. (AG)

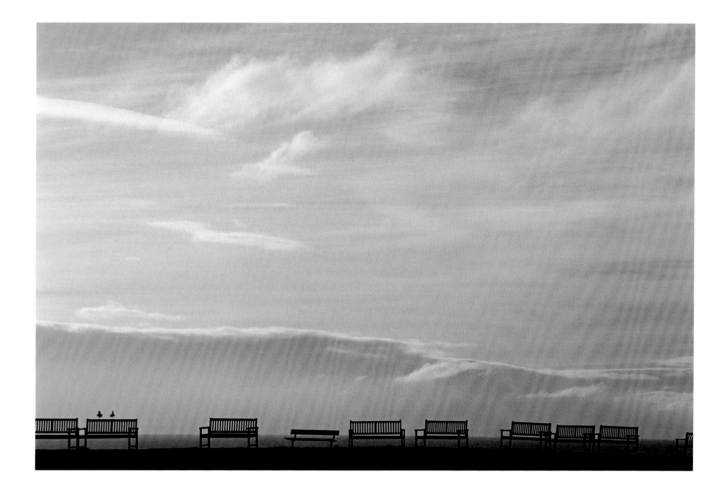

Although I was still fighting jet lag on a tour of the U.K., the possibility of a sunrise in Tynemouth, England, was enough to get me out of bed this fine morning. As I neared the coast, I saw the row of silhouetted benches. When I composed the image, I included as many benches as I could, emphasizing the horizontal line and giving prominence to the dramatic sky. Although tiny in the photograph, the two birds add a centre of interest to the image. I used a tripod to ensure sharpness and overexposed the transparency by one stop. (AG)

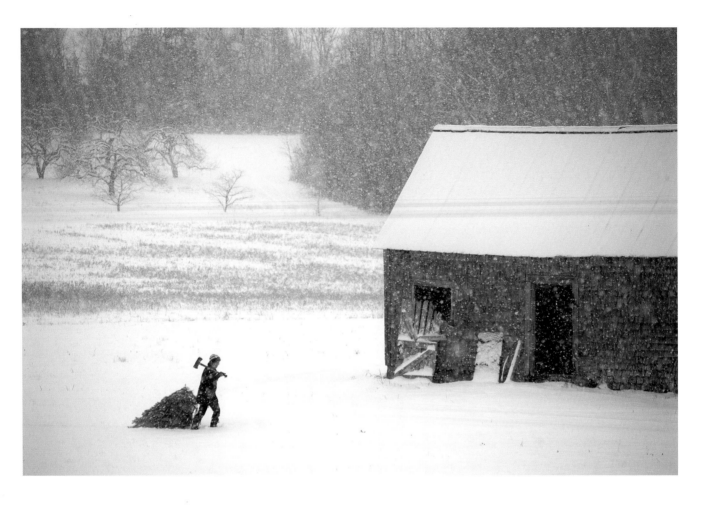

On a wonderful snowy January day, I asked my friend Kim to pose for me, hauling their Christmas tree in the snow. We hurried to find the right props (winter wear and an axe), loaded the dried-up fir tree in the SUV, and drove around until I found the right spot to photograph. When I saw the old weathered barn, I knew this is where I wanted to take my pictures. Thanks, Kimmie. (AG)

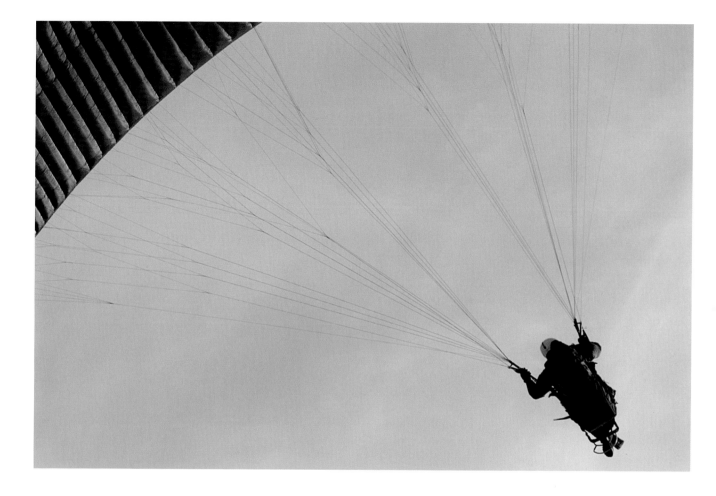

On a recent trip to Victoria, British Columbia, a friend took me to the coast to watch the sunset. Of course, I brought my camera along. I noticed movement in the sky and realized I was seeing not kites but paragliders. This was a fantastic opportunity to capture action shots. For the image above, I used a fast shutter speed ($\frac{1}{500}$th of a second) to freeze the action. (AG)

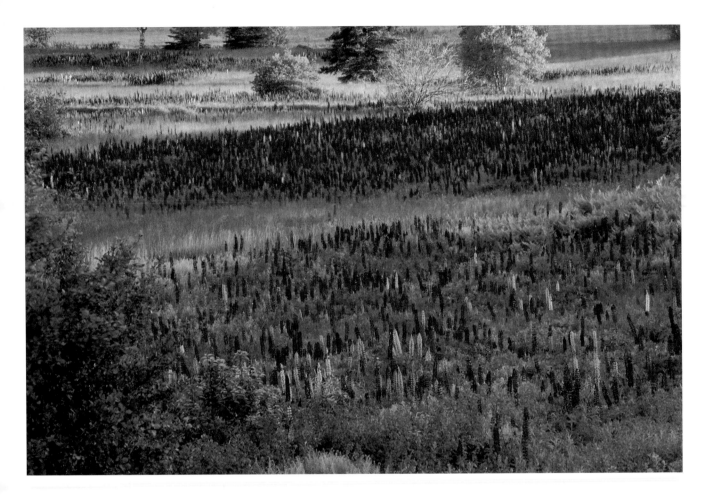

By mid-June the fields below my front deck begin to look like this. Many mornings I sit with a cup of coffee and watch the sunlight streaming first across the distant flowers and grasses, and then gradually across the nearer ones. Beside me is my tripod, mounted with a camera and a 100–300mm zoom lens. I may make photographs, or I may not, but the fact that I'm prepared for that special moment enables me to remain fully relaxed. (*FP*)

# CHOOSING YOUR TOOLS

# Cameras, lenses, and other equipment

If you've purchased this book, you probably have a camera and other photographic equipment and use it a lot. But, if you don't own a camera, or if you are looking for better equipment, here are some suggestions for you. Most of these refer either to digital or a 35mm single-lens reflex cameras. However, other types of cameras produce excellent images, and you may prefer one of them.

1   Think of your shopping around as an opportunity for learning. Study brochures on different brands of cameras and equipment, and ask your photographic friends or dealer to explain anything you don't understand. If possible, try out the models that interest you most—even if it means shooting at a friend's home or right in the camera store. You can't get "the feel" of equipment by reading about it. Whatever you do, don't hurry. Be methodical. Satisfy yourself before you buy that you are getting what you want.

2   Buy from a reputable dealer, especially one who is not given to high-pressure salesmanship. You have a lot to gain by dealing with and being thoughtful of an honest and considerate businessperson, even if prices on cameras, lenses, and other equipment are somewhat higher than they are down the street. If you buy your computer and cameras from the same dealer, the knowledgeable staff should always be forthcoming when you need help with digital. This kind of interest is worth the extra money in the long run.

## Cameras (digital and film)

There are many important items to consider when you are choosing a camera. These include:

1   **The total camera system.** Is there a variety of lenses and other equipment available for the camera model you are considering? Think carefully of your possible long-term needs even at this early stage.

2   **The camera's weight.** If you expect to carry your camera and other equipment for more than a few minutes at a time, or intend to use it on long trips, consider its weight carefully. If two models

seem equally good, you could be wise to get the lighter one.

3   **The lens.** Many cameras are offered for sale with a "standard" zoom lens, which is presumed to be what most people want, at least for their first lens. But you may not want a standard lens. If not, buy only the camera body, and purchase the lens you want to take the place of the standard one. (For a discussion of different lenses, see pages 30 to 34.)

Many lower-price-range cameras can only focus automatically. Auto focusing is a definite convenience for tracking moving objects and for many difficult lighting situations, but as there will be times when you want to focus manually (because you disagree with the lens' point of focus), we don't recommend these models for serious use. Make sure you can easily disengage the automatic feature. Even with the most highly sophisticated and versatile auto-focus system, you may occasionally want or need manual operation, and many photographers prefer to focus manually most of the time.

4   **The exposure system.** These days all cameras have an electronic shutter. Most single-lens reflex cameras can be operated in one of four possible shutter modes—manual, aperture-priority, shutter-priority, and program. In the *manual* mode, you choose both the aperture (lens opening) and the shutter speed you want; in the *aperture-priority* mode, you select the lens opening and the camera automatically chooses the shutter speed required for correct exposure; in the *shutter-priority* mode, you select the shutter speed and the camera chooses the lens opening; in the *program* or *fully automatic* mode, the camera chooses both the lens opening and the shutter speed, usually on the basis of the focal length of the lens you are using. In both the aperture-priority and shutter-priority modes, you can override the camera's decision (that is, overexpose or underexpose) by pressing an exposure compensation button. However, in most program modes, you cannot. (Many serious photographers rarely use this mode for precisely that reason.) Since all these exposure-system features are readily available, it's important to compare camera brands and models to find out which camera is best designed for your use.

Also, today's single-lens reflex cameras are likely to provide for automatic exposure with flash—a very useful feature for situations when you encounter low light or need "fill-in" light to reduce contrast. Again, make comparisons by examining various models of cameras and studying their instruction manuals. Can you switch to fully manual flash, if you want? Is sequence flash possible for action photography? The manuals will help you to ask and answer these and other questions.

The exposure system depends, of course, on the camera meter. (For a full discussion of meters and their use, see the chapter entitled "Exposure.") When you are contemplating a camera purchase, find out if the meter reads the light reflected from the entire picture area, or from just one spot, or from several key spots. Check to see if you can change from one area of measurement to another. For example, can you switch from an overall light reading to a spot measurement? This can be of great assistance in many situations, especially when the most important object in your picture is darker or lighter than everything else and you want to make sure you expose it accurately.

5 **Viewfinder screens, or viewing screens.** If you have difficulty focusing properly when you look through the viewfinder, check other viewing screens available for that camera model. Some screens have a grid pattern that helps you to keep your horizon and vertical lines straight. If you don't like the screen and there are no other screens available for the model, don't buy the camera.

6 **Depth-of-field preview button.** Every serious amateur will want to select the correct depth of field for every picture he makes. Make sure that the model you buy has a depth-of-field preview button or lever.

7 **Double and multiple exposures.** Consult the instruction manual or the dealer to find out whether or not you can make double or multiple exposures with the camera you are considering. Ask for a demonstration. Double or multiple exposure capability is not found on all brands or models of digital and film cameras, so make sure you inquire before making your purchase. (See the discussion of double and multiple exposures on page 119.)

8 **Self-timer or exposure-delay button.** Most cameras have a button that can delay the exposure for up to fifteen seconds from the moment you press the shutter release. This device will be important to you when you have your camera on a tripod and you want to get into the picture yourself. It's also useful when you don't have a cable release to prevent the tripod and camera from jiggling during an exposure. You can activate the self-timer, step back, and the exposure will be made a few seconds later.

9 **The price.** All brand-name cameras are carefully manufactured. Unless you require the ultimate in workmanship, there may be no good reason to buy a more expensive model when a less expensive model has most of the same features. Be cautious about buying a very expensive camera at a greatly reduced price—you may later find that extra lenses and equipment are not a bargain at all. A model offered at a substantially reduced price may be one that is going off the market, which could mean that in a few years parts and service may be hard to find. Most manufacturers service old models for a limited number of years only, so try to ascertain the duration. And remember, a good camera offered privately at a cheap price may have been stolen.

10 **The manufacturer's guarantee and service.** Your camera should be covered by at least a one-year warranty against mechanical defects. It's important to inquire from friends and your dealer about the speed and quality of service available for the camera you are considering. What's the point of owning a camera that takes two months to have repaired?

## Lenses

There are many different kinds of lenses available for digital and film cameras, but most photographers speak of three general types or "focal lengths": wide-angle, medium, and long focal length. These days most, but not all, lenses are zoom lenses. A zoom lens is a lens that covers a range of focal lengths, let's say from 17 to 35mm, or from 75 to 300mm.

Some high-end lenses come with a mechanism that helps to stabilize the lens when you are hand-holding the camera. With one of these, you can usually hand-hold your camera at two or three shutters speeds slower than if you were using a conventional lens. Canon calls

these "image stabilizer" lenses; Nikon refers to them as "vibration reduction" lenses; and Sigma uses the term "optical stabilizer." If you do a lot of street photography or hand-hold your camera often, these lenses may be worth their high price. If you normally use a tripod, as many serious amateurs do, you can probably depend fully on the less expensive, conventional lenses. (For a discussion of macro and macro-zoom lenses, see pages 37 and 38.)

**Kinds of lenses.** The "standard" lens for 35mm cameras for a long time was usually 50 or 55mm in focal length, because this focal length produced pictures in natural, realistic perspective. It's still useful to keep this in mind if only for discussion purposes. (The focal length of a 50mm or standard lens is roughly equivalent to the diagonal of a film negative or transparency.)

At the same distance from the subject, a *wide-angle lens* (35, 28, 24, 21, or 17mm for any 35mm camera; 24, 20, 16, 12mm for a non-full frame 35mm digital) produces a smaller image of the subject over the same area as a standard or longer lens, but it covers a larger field of view. The shorter the focal length of the lens, the smaller the subject image will be, but the wider the field of view will be. At the same distance a 25mm lens will produce a subject image approximately half the size of that produced by a 50mm lens, but it will cover twice the field of view.

At the same distance from the subject, a *telephoto* or *long-focal length lens* (100, 135, 200, 300, 500, or 1000mm, for example) produces a larger image of the subject on the same area of film as the standard lens, but it covers a narrower field of view. The longer the focal length of the lens, the larger the subject image will be, and the narrower the field of view will be.

At the same distance a 100mm lens will produce a subject image approximately twice as large as that produced by a 50mm lens, but will cover only half the field of view.

Lenses with a variable focal length are known as *zoom lenses*. For example, an 80–300mm zoom can be set at 80mm, 300mm, or at any focal length between.

The focal length of a lens influences its depth of field. Depth of field is the span of distance in your picture that appears fully sharp. (See also "Point of focus and depth of field," page 101.) A wide-angle (short focal length) lens gives greater depth of field than a standard lens, and a standard lens gives more than a telephoto (long focal length) lens. The shorter the focal length, the greater the depth of field; the longer the focal length, the less the depth of field. An 80–300mm zoom lens will show considerably greater depth of field at 80mm than it will at 300mm.

**Uses of lenses.** Lenses of different focal lengths and especially zoom lenses give a photographer much greater control over the scale of his subject matter and over apparent perspective. Consequently, lenses play a fundamental role in the composition of photographs. Let's consider some ways to use the different lenses.

The secret of using a *wide-angle lens* effectively often lies in paying attention to the foreground of the composition. A strong foreground object, relatively large in the composition, helps the viewer to judge the scale of the other objects in the picture. Neglect the foreground, and you are usually in trouble when you compose with lenses from 12 to 35mm.

Wide-angle lenses are usually used to best advantage when you hold your camera vertically. This reduces the picture's width, but produces a tremendous sense of

depth. In a mountain region, for example, try positioning the camera vertically and including a stream, a rock, or a clump of alpine flowers in the immediate foreground, and let the rest of the picture sweep away to the towering peaks.

When you use a wide-angle lens for a landscape, don't be afraid to move in very close to the foreground object. Try tilting the camera down to provide a little space underneath the foreground object, then inch it up again to include just a "sliver" of sky as in the photograph on page 145. On the other hand, by tilting the camera up toward the sky and retaining only a small amount of land at the base of the picture area, you can produce a striking sense of space, but not so much depth.

There are two other uses for wide-angle lenses. First, if you want to reduce the size or impact of a secondary object in the composition, use a wide-angle lens and position yourself close to the main subject. Second, if you want to show the main subject of your composition in a typical environment (for example, the mayor in front of the city hall, or flowers in their natural habitat) a wide-angle lens can be valuable. Moving close to your subject matter will give it prominence, and at the same time will capture a large part of the setting. Your picture will tell a story neatly and quickly.

Use your wide-angle lens courageously. Capitalize on its unique characteristics. Avoid thinking of it as a lens that merely helps you to include more things in your picture. Wide-angle lenses from 20 to 28mm are sensible choices for many photographers. A 35mm may be too close to the 50mm standard lens for your taste, and a 16 or 17mm may create visual distortion that you don't like.

A *telephoto lens* compresses distance and diminishes apparent perspective, introducing new visual elements into a composition. Chief among these is the close grouping (telescoping) of objects that are actually far apart. Also, because a long lens has a narrower field of view than a standard lens, it may lead to simpler design. The number of visual components is reduced. These factors, along with shallower depth of field than a standard lens, mean that a long lens forces you to see differently.

For example, a telephoto lens enables you to shoot *through* foreground material, such as grasses or wire fences, showing them as vague forms at maximum apertures (such as f/3.5) and sometimes eliminating them altogether. The shallow depth of field that causes objects near the lens to be out of focus can be used effectively in visual design. If you poke a long lens, let's say a 300mm, partly through a bush and let the autumn leaves cascade in front of the lens, perhaps even touching it, while you focus on a friend who is standing fifteen metres beyond, you can make a picture in which she will be in sharp focus, but surrounded by gentle swirls of colour. The shallowest depth of field will make the leaves blurred and soft.

You may spot late afternoon shadows from a row of trees falling across a country road. Because a long lens covers a narrow field of view, you can isolate the shadows. And since the lens also compresses distance, the shadows will appear "stacked up," one behind or on top of the other. When a cyclist appears in the distance, you could capture him as he passes momentarily between two shadows and into the sunlight, providing a striking contrast to the linear composition and establishing a definite centre of interest. The photograph on page 26 shows the effect of using a telephoto lens for this kind of image.

Most photographers buy a *zoom lens* or lenses. The advantages of a zoom are easy to see. First, you are buying not merely one lens, but a series of lenses wrapped up in a single package. A zoom lens enables you to make compositions impossible to achieve even with a choice of four or five different lenses, because a zoom allows for the most minute adjustments over its entire range. Also, the price is usually right. A zoom lens may cost more than a fixed-focal-length lens, but what you gain in versatility is worth the extra cost. And it's a lot easier to carry around one or two lenses than several. For example, a 24–85mm and a 100–300mm zoom lens will provide a range of focal lengths adequate for many photographers' needs much of the time. Even if you already own a long lens consider buying a 100–300mm zoom, for example. This range of focal lengths will be more useful to you than a longer zoom, such as 300–600mm, unless your needs are highly specialized.

Another way to obtain telephoto capability with 35mm single-lens reflex lenses is to use a *tele converter*, an optical device that doubles or triples the focal length of a lens. With tele extenders the minimum focusing distance of the original lens remains unchanged, which is important. However, less light reaches the film, and images may be distorted, a disadvantage that is not too evident at small lens openings. A good tele converter combined with a good lens can make a useful combination; but a tele converter will magnify optical faults as well as the image size, so a good tele converter with a poor lens can be a bad combination.

**Lens speed.** There is another characteristic besides focal length by which lenses are classified. This is speed. The speed of a lens is determined by its largest aperture. The smaller the number of a lens' widest opening or f/stop, the *faster* the lens. For example, a lens with a maximum aperture of f/1.2 is faster than one of f/1.8 or f/3.5.

The speed of a lens affects two aspects of photographic control—exposure and depth of field. The faster a lens is, the shorter the duration of exposure can be. For instance, if you have two 100mm lenses, one with a maximum aperture of f/4 and the other with a maximum aperture of f/2.8, you may have to shoot at $\frac{1}{30}$ second at f/4 with the first lens in order to expose properly, but under the same light conditions you can use the second lens at $\frac{1}{60}$ second at f/2.8—half the exposure time. However, the faster lens will give you less depth of field at its maximum aperture than the slower lens.

Most manufacturers offer more than one speed of lens for a given focal length. There are often two 300mm or 100–300mm zoom lenses available for a particular camera, for example. Given a choice between a 300mm f/5.6 lens and a 300mm f/4 lens, consider buying the slower lens for three reasons. The *first* and most obvious reason is price. The slower lens will probably be quite a bit less expensive than the faster one. The *second* reason is size and weight. The faster lens is likely to be bigger and heavier. This means that if you are hand-holding your camera at a sports event, you'll have to use a higher shutter speed with the faster lens—in order to overcome camera movement—than you will with the slower one. The *third* reason is optical quality. Many slow lenses have a long history of development and use so that most aberrations have long since been removed.

Putting your camera on a tripod still won't give you an edge with the faster lens. For example, if you are

using an aperture of f/11, you'll need the same shutter speed for both lenses to get equivalent exposures. If you are using maximum apertures on both lenses, you will require one shutter speed slower for the f/5.6 lens than for the f/4, but since your camera is held steady on a tripod the slower speed won't make much difference to you in most circumstances. In short, don't buy fast tele-photo lenses unless you have personal reasons for doing so, reasons that have emerged clearly from the specific technical demands of your photography.

The same advice is relevant for wide-angle and medium-focal length lenses. Many photographers never require fast lenses such as f/1.2 and f/1.4. An f/2.8 lens is more than adequate for nearly every conceivable exposure situation, and allows you to achieve extremely shallow depth of field whenever you want it. So, when you have a choice, consider buying a slower lens, rather than a faster one, and use the money you save to buy a good frame for a fine print.

## Tripods

There are two important reasons for using a tripod. It steadies the camera, and it induces visual and technical discipline. Either reason is sufficient cause for buying and using a tripod. Together, they are compelling causes—especially for the beginner.

It's quite true that there are some kinds of photography for which a tripod is always a hindrance, such as candid photography of people and certain sports, and if you specialize in one of these areas you won't use a tripod very often. It's also true that every photographer from time to time encounters situations where a tripod is a great bother. But for most photographers most of the time, there is much to be gained by standing your camera on three legs. Cameras, like people, function best when they are well supported.

Take steadiness. Careful tests have proven that hand-held pictures taken at $\frac{1}{60}$ second on a 35mm camera just aren't as sharp as pictures made with a tripod-supported camera. You don't have to enlarge your negatives, transparencies, or digital files very far in order to see the difference—even if you're as steady as the Rock of Gibraltar and often attempt shooting at speeds as slow as $\frac{1}{8}$ second.

Take discipline. The very act of placing the tripod in position induces care in making the photograph. You compose a photograph in the same way as when you are hand-holding; if you don't like your camera position, you can easily reposition your tripod until you find the precise viewpoint you want. Or, you can make a composition and then wait for the sun to appear or disappear behind a cloud. But because the tripod, and not the photographer, is holding the camera, you don't get tired keeping that position. Fewer kinks in the elbows!

You'll find it easier to consider the design of each image and make fine adjustments when you are using a tripod. You'll be able to study the effect of lines more carefully, and note more accurately the proportion of the main subject in relation to the entire picture space. And, if light is fairly constant, you can study the intensity of light in different areas and note the tonal relationships between these areas. If you buy a tripod when you begin making photographs and use it constantly, you will help to educate yourself visually and you will be forever grateful for the wisdom of your decision. We cannot stress this too much.

Here are some important factors to consider when you select a tripod:

1   A tripod should be sturdy, unlikely to tremble in a strong wind or to fall over under the weight of your heaviest camera or longest lens. However, you do not need a big or heavy tripod unless your camera is large and you have some very long or very heavy lenses.

2   A tripod for 35mm or slightly larger-format cameras should *not* have a pan head, which is invariably what is fitted on top. Most digital photographers will not require a pan head either. This pan head is for video cameras, not still cameras. Frankly, the pan head is often a curse. Before you leave the camera store with your new tripod make sure that you can unscrew the pan head. Give it back to the clerk and buy a ball-and-socket head or pistol-grip type of head in its place. *We prefer those that have a single lever or knob to adjust.*

A good head allows you to swivel your camera on the tripod, to tilt it easily in any direction, and to lock it instantly where you want it. It enables you to make very minute adjustments in composition, so you'll find it easier to get precisely the design you want. These things are much more difficult to do with most pan heads, and besides, a pan head has a handle that often sticks out where you don't want it.

A good head should be virtually indestructible, versatile, simple to use, easily hold lenses up to 400mm and even longer; it will make working with your tripod a real joy. A good head may seem costly, but it is worth every cent of the price. There are also several good brands and models. Check and test them. Don't accept anybody else as the final authority on what you should choose, especially the clerk in the store.

3   At the tripod's minimum height you should be able to spread the legs wide enough to permit the use of close-up equipment for subjects on the ground.

4   The legs should have adjustable rubber tips that will screw down to protect floors and carpets.

5   Examine the construction of your tripod to see how the legs are attached. Watch out for tripods that have screws or nuts on the inside of the legs near the top. If these screws come loose, it may be nearly impossible to tighten them because of their position. Also avoid rivets in hinged joints as they cannot be tightened.

6   A tripod for 35mm (or smaller) digital or film cameras does not need leg braces attached to the centre post, unless you often use very long lenses and require the extra stability.

7   A tripod that has clips or twist knobs for extending or shortening the legs is usually easier to operate than one with rings.

8   A tripod should have a centre post that is easy to remove, preferably one that does not have gears and a crank. Sometimes you may want to place your camera upside down between the legs in order to get a better composition. The removable post permits this, as well as the insertion of a very short centre post (which you can usually buy with the tripod as an extra). Some tripods have a centre post in two parts, so you can unscrew the long section and have only a short post when you need it. Other tripods allow you to remove the centre post and position it horizontally for working near the ground.

9   A small, fully collapsible tripod is very useful for long hikes, sports events, and travel by air. A good size for most suitcases is one that does not exceed

fifty-six centimetres in length and nine centimetres in diameter, and weighs two kilograms or a little less.

10 Buy a couple of cable releases when you get your tripod. A cable release allows you to trip the shutter without touching the camera, which assures that the tripod will not shake during the exposure. A locking cable release is useful for long time exposures.

We'd like to pass on a suggestion about using your tripod. Once you've completed your composition, stand back before you press the cable release. *Don't hang on to the tripod.* Don't keep peeking through the viewfinder, unless you're watching a moving object. And don't bounce up and down on the surrounding earth. Stand up, stand back, and stand still, and make your photograph with the confidence that you've done everything you possibly can.

Finally, if you feel your tripod or head is a pain to use, then you have purchased the wrong one. May we suggest that you take your camera to the store and try out what you think you'll buy before you make the purchase.

## Flash

An electronic flash unit may be extremely useful, depending on the kind of photography you do. If you are a parent with small children around the house, a flash can be a worthwhile investment, although these days most cameras have them built in. If your interest is primarily landscapes and holiday scenes, think twice before you buy. (For discussion of flash and how to use it, see "Using flash," pages 116 to 118.)

## Filters

You'll need filters much more frequently for film than for digital imaging, and for black-and-white photography more than for colour. A great many colour photographers rarely use filters. In any case, if you're buying filters for use with film, you'll need one set for black-and-white and another set for colour.

**Filters for digital imaging.** About the only filters you will need for digital imaging are polarizing and neutral density filters, as you can make all other adjustments or corrections after transferring your images to a computer. (Read about this filter in "Filters for black-and-white and colour film photography" on the following page.)

**Filters for black-and-white film photography.** Black-and-white films reproduce all colours as tones of grey. A bright red object may turn out to be almost the same tone of grey as a rich green one on black-and-white film. The two objects will lack the contrast that colour provided. In order to ensure that you have contrast between the two, use a filter to make the red and green appear as different tones. A green filter will block much of the red reflected from the red object, but will allow the green light from the green object to reach the film. Thus, the red object will be underexposed or darker than the green one, and contrast will be achieved. A red filter will perform in the reverse manner, making the red object a much lighter tone of grey than the green object, but you will still have contrast. A yellow filter will darken a blue sky, and a red filter will darken it even more, making clouds stand out dramatically.

Pick up a manual on filters for black-and-white films at your camera store, and study it before you buy your filters. When you purchase a set of filters, don't wait until

you need them before you use them. Experiment with them right away so you can see the results. Then when you do need a filter, you'll know which one to choose.

Most filters require some exposure correction. The filter manual, or the instruction sheet, will tell you what aperture or time adjustment is needed. It is not always wise to assume that the camera light meter will give the correct exposure, as some types of meters may be more or less sensitive to certain colours. Experiment and mark the filter rim with any correction that is needed.

**Filters for colour film photography.** Filters for colour films shift all the colours in a photograph toward the colour of the filters. A blue filter makes everything bluish; a yellow filter makes everything golden. Usually, filters for colour films are used to "correct" inappropriate colour. For example, tungsten lights cast a very warm glow. If you use daylight film to photograph a person who is illuminated by a light bulb, her skin will appear red. If you add a blue filter to the front of your lens, your subject will have more normal skin colour, because the blue will balance the colour of the warm light.

However, if you're not concerned about "true" colour, then you can use a filter to produce any colour effect you want. If you've discovered a stunning pattern of cracks in the sidewalk, but have no intention of photographing it in a realistic manner, you may add a colour filter to enhance the unreality. You can even use a filter designated for black-and-white films and give very bold colour effects. The colours in these filters are much more intense than in filters for colour films.

An ultraviolet or uv filter is useful for colour photography. It eliminates ultraviolet light, thus reducing bluishness and haziness in long distance and aerial shots.

Many photographers put one on a lens when they buy it, and never take it off. The colour effect is very slight, and the filter protects the front lens element.

**Filters for black-and-white and colour film photography.** A polarizing filter or polascreen can be used with both colour and black-and-white films and for digital imaging. This filter can be very helpful when bright tones distract from your composition. A polarizing filter does not block all reflected light, but only the light that is polarized light waves that are oriented at one angle instead of several. You must rotate a polarizing filter on the front of your lens to find the position that will eliminate the amount of polarized light you want removed. Because a polarizing filter blocks out some light, it affects exposure. There are slight variations in different makes of polascreens, but generally they require shooting with the lens opening increased by $1\frac{1}{3}$ f/stops, or by $\frac{1}{3}$ stop and one shutter speed slower.

A neutral density filter can also be used for both black-and-white and colour photography. It simply reduces the amount of light reaching the film. This filter is especially useful when you are photographing in bright sunlight with high-speed film and you need a slower shutter speed to record motion or a larger lens opening to get a shallower depth of field. Neutral density filters are available in various densities, each reducing the exposure by a specific amount, and in decreasing densities from one edge to the other (called "graduated" filters).

## Close-up equipment for digital and film cameras

Macro lenses, extension tubes, and close-up filters are photographic tools that enable you to focus on objects

close to the lens—much closer than the usual minimum focusing distance. If you are interested in nature photography, especially close-ups of flowers or insects, you'll need one or more of these tools. But, they can be used for other subject matter too (see photo on page 127).

A *macro lens* is probably the best answer to most photographers' needs for close-up work. For practical purposes a macro lens is an ordinary lens (usually 50mm or 100mm) that also focuses on objects much closer to the lens than regular lenses do. With a macro lens, you can shoot a landscape one minute and a bee landing on a flower the next. It's merely a matter of focusing.

A 100mm macro lens is an excellent choice. This is a medium telephoto lens with close-up capability. A 100mm macro will focus only about half as close as a 50mm macro, but because a 100mm lens produces twice as big an image as a 50mm lens, you will end up with the same capacity for making close-ups. And, the 100mm macro offers one real advantage—you can stand twice as far from the subject, yet get the same size of image that a 50mm macro would give. This extra distance can be very useful when you are photographing nature subjects, such as insects or grasses covered with dew, because it's easy to frighten some insects or to bump into the grasses and knock off the drops. The photographs on pages 69 and 134 show the types of close-ups you can make with a macro lens.

A macro lens has one drawback, unless you use an extension tube or close-up filters (see following paragraphs) with it—it doesn't allow you to magnify your subject. Its maximum capability is a life-size image in the 35mm viewfinder or on a slide or negative *prior* to projection or enlargement.

A *macro-zoom lens* would appear to be the ideal lens, combining as it does zoom capability plus the capacity for making close-ups. But you don't want a lens that's heavy, awkward to work with, or of dubious optical quality. Also, the close-up capability of most macro-zooms is less than that of ordinary macro lenses. Test before you buy, even if you have to spend an hour zooming and making close-ups right in the camera store. Make sure you try all the f/stops at both the minimum and maximum range of the zoom and in the macro position. If the resulting pictures are sharp at every f/stop and you find the lens easy to work with, then consider a purchase. A macro-zoom makes sense if you have neither a zoom nor a macro at present.

One final note about close-up equipment—you can use various combinations of equipment to get better close-ups or to magnify your subject. For example, it's possible to use extension tubes behind your camera lens with the close-up filters in front of it. It's a good idea to try out various combinations and to make some notes on how well they work. How much enlargement do you get? Is the combination of equipment easy or difficult to work with? If you are familiar with the possibilities, you will be able to choose the right combination of equipment when you need it.

*Extension tubes* (and *bellows*) are devices that you insert between the camera and the lens. You screw or snap the tubes or bellows into the lens mount, and then you put the lens on the other end. Neither tubes nor bellows have any lens elements in them. They merely extend the distance of the lens from the film, which results in your being able to focus on close-up objects. The main difference between the two is that tubes are of fixed lengths, but bellows can be shortened or

lengthened and may also have a greater focusing range. (Bellows used to be in common use, but are seldom, if ever, seen these days, except on some very large-format cameras.)

Extension tubes usually come in sets of three, and you can use any one by itself or in combination with the others in order to focus where you want. Tubes are lightweight too, but they have a disadvantage. Since they only give you a shallow focusing range, you must either try different combinations of tubes, or move the camera to the precise spot to get the image you want.

Although it may seem odd to anybody who does not know much about optics, the shorter the focal length of the lens you use in front of extension tubes or bellows, the larger the image of your subject will be. Conversely, the longer the focal length of the lens, the smaller the image of your subject will be. The ideal range of lenses to use with tubes or bellows is from 50mm to about 135mm. Shorter lenses force you to move so close to the subject that you may bump into it, while longer lenses may be very difficult to support, and actually require a second tripod for support. However, there are exceptions. It's possible to use a 400mm lens in front of a bellows, if the lens and bellows are constructed to work together.

*Close-up filters* are like extension tubes in that they come in sets, usually of three, and may be used singly or in combination with one another. They are fairly simple to use, because you don't have to remove your camera lens in order to change close-up filters, but you will have to reposition your tripod and camera with each new close-up filter or combination of close-up filters. Unlike extension tubes or bellows, close-up filters do not reduce the amount of light reaching the film, and

require no exposure adjustment. Also, unlike extension tubes and bellows, they magnify more when used with longer lenses than shorter ones.

The major drawback of these filters used to be their relatively poor optical quality, which produced pictures that were not very sharp, especially at the edges. The lack of sharpness increased with the number of close-up filters used together. Nowadays this is less of a problem, since close-up filters are manufactured to high standards, but it is still a consideration if you expect to make a sizable enlargement from a negative. Extension tubes or bellows, which have no lens elements, do not interfere with the optical quality of the camera lens. Photographers who never expect to print their images, only to project them, probably don't need to worry very much about any loss of sharpness that might occur with close-up filters, because projector lenses and screens reduce sharpness. So if close-up filters do cause a lack of sharpness in colour slides, it is unlikely to show in the projected image.

### Assessing your needs

Buy only the equipment that will help you make the pictures you want. For instance, if you use your camera extensively on trips and holidays, and want versatility without carrying too many items or too much weight, consider the following combinations of equipment: 1/ a 17–35mm wide-angle lens, a 50 or 55mm lens, and a 80–300mm zoom lens, plus a set of extension tubes; 2/ a 24–85mm zoom, an 80–300mm zoom, and one set of extension tubes, close-up lenses, or a macro lens; 3/ a 24–85mm zoom and an 80–300mm zoom, one of which has macro capability. Many photographers will have at least one of the above items, and will need

to add only one more item to complete a set. (These are only examples. Non-full frame 35mm digital camera users may want to consider different choices.)

If you photograph mainly people in your home or neighbourhood, or are primarily interested in arranging and photographing still lifes, draw up similar brief lists of equipment that will meet most of your needs. It's a quick way to identify the equipment you still need.

Remember that photographs, not equipment, are what photography is all about. Seeing and making pictures is the real challenge. The simplest equipment can be sufficient to give you years of enjoyment, as long as you keep exploring its potential. So, when you buy something new, make sure that you are investing not only in equipment, but also in new visual experiences.

## Caring for your equipment

Virtually all cameras and lenses are so well-constructed that the amateur need never worry about wearing them out or damaging them, short of a major accident. This does not mean that every part will always function perfectly. The shutter may jam, the self-timer may stop working, or the meter may go on the blink, but it is rare indeed to find a camera that has succumbed to old age.

Perhaps the most common fear is what will happen when a camera gets wet. The answer is, probably nothing. Don't stay inside just because it's raining. Go out, but be sensible. Keep your camera inside your coat or camera bag until you are ready to use it. If it's raining very hard, cover it with a small sheet of plastic or shower cap when setting it up. One photographer we know has, on her tripod, a clamp that will hold an umbrella handle. The umbrella keeps both the camera and the photographer dry. A friend sometimes wears a big black stetson over the hood of his raincoat on a wet day; when he wants to leave his camera sitting on the tripod for any reason, he places the stetson over his camera and walks away. (This has been known to hold up traffic. A black stetson with three metal legs is not something you see by the roadside every day—even in Alberta or Montana!)

If your camera gets very wet, wipe it off gently when you come inside. Dry the lens with a very soft chamois or lens tissue. If you suspect that water has leaked inside, remove the lens and dry out the interior of the camera with the gentle flow of warm air from a hair dryer. You can do the same thing with the back of the camera, after you've rewound your film of course. The hair dryer is a very useful tool, particularly in an emergency. A couple of photographers we know have used it to dry out a camera which they dropped into a brook—and apparently with complete success; but they were lucky!

If you drop your camera into salt water, however, you are in trouble. The best advice we can give is "Don't do it!"—especially if it is not insured. Salt corrosion is the biggest danger; so, as soon as possible (preferably before the camera dries at all), submerge it in fresh water and rinse, rinse, rinse. Then prepare to spend an afternoon with the hair dryer. This may salvage the camera, but it is less likely to help the lens. Don't hold your breath—in either case. The chances for rehabilitation are not good, especially with modern electronic cameras.

Perhaps the greatest threat to the average camera and lens is getting dirt or sand into moving parts. If you do,

don't muck about! Get the equipment cleaned professionally. Don't worry about a little dust on the lens, because it won't affect optical quality. Get rid of it when you must with a small air blower (available at any camera store), and remove anything sticky with a tiny drop of lens cleaner absorbed in lens tissue or a very soft chamois. Some very careful photographers don't use liquid cleaner at all, but simply breathe (*not* blow) on the lens and then wipe it with the chamois or lens tissue. Before you use a chamois for this purpose, it should have been washed a few times to remove stiffness. Use a real chamois, not an imitation.

If you shoot with a digital camera, you will notice that small specks sometimes appear in your images. That is because the camera sensor attracts dust. A safe and easy way to clean a digital camera is to use a blow brush and blow air on the sensor. Never use compressed air to do this, as it can easily damage the sensor beyond repair. Another option is to use fine demagnetized brushes made specifically for cleaning camera sensors. You can find these at finer camera equipment stores. (They are expensive.) If some dust particles are difficult to dislodge, you can use a cleaning solution and soft swipes that you can also buy at your camera store. If all these fail, have your camera checked by a reputable shop or, even better, by the manufacturer. Some digital cameras have a self-cleaning sensor unit that automatically removes dust on the sensor. This is an attractive feature that will eliminate time spent on the computer cleaning images when processing your digital files.

The best way to care for your equipment is simply to use common sense.

1. Keep your camera clean inside and out by careful wiping, or by brushing with a camel-hair brush, or by blowing air from a small air blower. Both brush and blower are available from your camera dealer. Sometimes they are manufactured and sold as a single unit. If dirt or dust accumulates on the reflex mirror of a film camera, use only a blower to remove it.

2. Keep the cap on the lens when you aren't making pictures, and also make sure a cap is on the rear of the lens when the lens is off the camera.

3. Shut off the light meter when you aren't using it to protect the life of the battery.

4. Buy a small jeweller's screwdriver and periodically check all the tiny screws on your camera and lenses, especially after a long plane flight, which may loosen them through vibration.

5. Don't force any moving parts that seem to be stuck or locked, especially in cold weather.

6. Remove the camera from its case when you put it on a tripod; it may be nearly impossible to remove both camera and case later on, if you don't.

7. Pack your equipment carefully for travelling, taking special care to ensure that no lenses or cameras will bounce or rub against each other.

8. Don't leave your camera lying around or standing on a tripod where children are playing or when the wind is blowing.

9. Don't store your equipment or film where it will be subjected to high temperatures or humidity, especially for a long period. If possible, store your film at below 12°C.

10. Have your camera professionally cleaned and checked every couple of years, or more often if you have been using it frequently.

Because cameras are so well-constructed, a photographer does not have to treat them with kid gloves. Cameras are made to be used, not admired. If you badly want a photograph that involves some risk to your equipment, take the risk. Cameras are replaceable; opportunities are not.

# Digital capture

As teachers of photography workshops, we've watched as the number of participants shooting with digital cameras is constantly growing. An important reason to consider digital imaging is the control it brings to photography. Being able to see instantly what you've just captured is an incredible asset to making photographs. If you haven't quite captured the shot you intended, you can try again until you get it just right. And, using a photo processing program, you can brighten or darken images, add or reduce contrast, or crop a photograph with a click of the mouse.

Shooting digital pictures is not that different from shooting film. The camera's functions are the same; the difference lies in how the images are transmitted. Rather than being recorded on a negative or a transparency, your photos are recorded on a sensor and transmitted to a memory card. You transfer the images from the card to your computer, where you can store the ones you want to keep. Eventually, you will want to save them to a CD-R, DVD, or some other form of back-up media. It is a good practice to copy images onto a CD-R or DVD right after the shoot to preserve them in case they are accidentally deleted or become no longer accessible due to a computer failure.

Beginners will find that learning to make good photographs is easier on a digital camera, as you can catch and correct your mistakes right away by looking at the display screen (LCD monitor) on the back of your camera. You no longer have to wait for film to be processed.

The key to learning digital photography is to do it one step at a time and at your own pace. If you shoot film and are thinking about learning digital, you should make the transition gradually so it won't overwhelm you.

## *Benefits of the digital camera*

A number of advantages come with shooting digitally. Perhaps the biggest one is that you can review the images you capture on the LCD monitor on the back of your camera. The image on the monitor, though small, will give you a good sense of your composition and exposure. When photographing people or animals, you'll be able to see if their eyes are closed and if their

expressions are acceptable. You can then delete images that don't satisfy you and try again, making appropriate corrections. One word of caution: Don't be too hasty with the delete button; you can throw away good images too easily. Your images will look much different on the computer screen than they do on the tiny LCD screen, and you may find that a photo is better than you originally thought it was. Even if the photo as a whole isn't what you were going for, you might be able to salvage something from the image by cropping it (see Rotating and Cropping, page 49).

The LCD screen can be benefical when taking photographs of people because you can immediately share with them the images you have taken. Kids love looking at cameras and pictures, and adults appreciate seeing how they look in your photographs.

Another benefit of the digital camera is the ability to change the ISO at will. As with film, the best quality comes from using a low ISO, such as 100, where grain is less inherent and colour is more saturated. The higher the ISO, the grainier the image, both on film and digital (grain is called "noise" on digital). However, if you have taken a digital image that has too much noise, there are programs available that can reduce noise.

With the use of the histogram on digital cameras, you can assess your exposures, making sure you have enough detail in the shadow and highlight areas. The histogram is a graph that shows the tonal range, exposure, and contrast in your photographs. It most often looks like a mountain sitting on the horizon, with highlights to the right and shadows to the left. Ideally, the mountain should not be cut off at either side but should slope down towards the horizon on both sides. You are losing shadow detail when the mountain is cut off on the left,

and blowing or washing out the highlights when it is cut off on the right. When shooting digital in brighter- or darker-than-average scenes, you'll need to compensate a bit less for exposure than you would when shooting with transparency film. Rely on what you see on the LCD screen, in combination with the histogram. If all else fails, you can fix the brightness and contrast to a certain extent when you are processing the image onscreen.

Another unique feature of the digital camera is white balance control. This feature is like having a set of filters built into the camera, and it is extremely useful when shooting under artificial light. You can set it to get rid of the green cast under fluorescent lighting or the warm orange hue under tungsten lights. Review your camera manual carefully to make sure you understand how these different settings will affect your photographs. Unless you are shooting indoors with artificial light, your preferred white balance setting will probably be for natural light (usually illustrated with a sun icon). The Auto White Balance (AWB) is an automatic setting, but like all automated features it's not necessarily the ideal setting. Always strive for what you want, rather than what the camera wants to show.

When you shoot digital images, your computer becomes your darkroom. After transferring your images on to your computer, you can view and process them using programs such as Adobe Photoshop (extremely popular with photographers, printers, and graphic designers), Jasc Paint Shop Pro, or Deneba Canvas, among many others. Standard darkrooms require lots of space, running water, an enlarger, chemicals—and you need to work in the dark. Today, you can sit at your computer, process your images with tremendous

control, and produce prints of extremely high quality.

With a photo processing program, you can be very creative, perhaps producing montages or stitching images together to create panoramas. You can get rid of unwanted elements in a photograph, such as electrical wires cutting across an urban scene. You can convert colour images to black-and-white, then tone them if you wish, and maybe add a touch of colour to part of the image, or all of it. You can add artistic elements to your photos, such as distortion or texture. It's great fun to experiment with your software, exploring all the creative possibilities.

## Purchasing a digital camera

Before you can start to shoot digital photos, you'll need a digital camera. This technology has advanced rapidly over the past few years and continues to evolve at lightning speed. Digital cameras now range widely in price and quality. So what should you be looking for from your purchase? First, you need to ask yourself, "What do I want to do with my photographs?" Do you mainly want to photograph your children and take snapshots at family events? Do you intend to share your photos by email only, or will you want to print them? Are you hoping to get published and perhaps sell prints? The answers to these questions will help determine the file size you need and what features you should look for in your equipment. You have two basic options: a point-and-shoot camera or a single-lens reflex camera (SLR).

*Point-and-shoot cameras* have come a long way, and many people find them to be a good choice for a basic digital camera. Their compact size makes them easy to carry around, and especially to travel with. Most come with zoom lenses, some covering amazing ranges in a camera of such a small size and at such affordable prices.

File size is an important consideration when buying any digital camera. The more megapixels a camera has, the better the quality of the images, both onscreen and in print. A 3-megapixel point-and-shoot will produce good-quality prints up to 5 × 7 inches (12 × 18 cm). With a 5-megapixel camera, you'll be able to print at 8 × 10 inches (20 × 26 cm) or a bit more.

Here are some other features to consider when purchasing a digital point-and-shoot camera:

**Physical size:** Are you looking for a camera that will fit in your pocket?

**Exposure modes:** Aperture priority, shutter priority and manual modes give you more control over your photography than a fully automated camera.

**Self-timer:** This is a useful feature if you want to be included in the photograph.

**Anti-shake/image stabilizer:** This feature helps you capture sharper photographs and allows you to photograph in lower-light situations.

**Red eye reduction:** Useful in eliminating red eyes when using flash.

**Shutter lag:** Avoid cameras with shutter lag (the pause between the time you press the shutter and the time the photograph is actually taken)—it will cause you to miss spontaneous moments.

When buying a *single-lens reflex (SLR) digital camera*, there are many brands to choose from and lots of decisions to make about the options you want. With a bit of research and a few trips to a good camera shop with informed staff, you'll be able to choose a camera

that suits your needs. It may be worthwhile to stick with a well-known brand that has been dedicated to photography for a long time. If you already own a 35mm film camera, it is usually possible to use the lenses you already own on a digital body of the same brand.

File size is a vital consideration. Top-of-the-line digital cameras have a full-frame sensor, delivering an impressive 16- to 22-megapixel file. Made for professionals, these cameras are very expensive. The quality delivered by these cameras is comparable to that of film, and some professionals claim it surpasses film. Film is so good, however, that this claim holds no advantage for the average photographer. Cameras delivering 12 to 16 megapixels will satisfy the demands of most professionals and serious amateurs. These cameras usually have a full-frame sensor. Cameras in the 8-megapixel range perform extremely well, but some have smaller sensors. Most cameras in the 8-megapixel range do not use a full-frame sensor, so they have a smaller angle of view than 35mm film cameras. This means an increase in focal length by a factor of 1.5 or 1.6. So your 300mm lens will become a 450mm lens, and your 24mm lens will have a reduced angle of view similar to a 35mm lens.

Here are some other features to bear in mind when choosing your camera:

- The size of the LCD panel. The larger the screen, the better you can examine your captured images.
- Availability of a variety of lenses, including image-stabilized lenses.
- Double- or multiple-exposure capabilities. These are not standard to all brands or models. If this feature is

important to you, check to make sure the camera you intend to buy has it.

In addition to the camera itself, most digital camera purchases come complete with accessories such as a camera battery, a memory card, a cable to connect your camera to a computer or a photo printer, and photo processing software.

Digital cameras consume a lot of power, so look for one that comes with a rechargeable battery. Otherwise, you will end up spending a fortune on batteries. It's best to keep at least one spare battery fully charged at all times so you'll never be faced with the frustration of having your camera run out of power just when a photo opportunity presents itself. Also, keep in mind that you use more power by displaying images on the LCD screen than by using the viewfinder to compose your images as you would with a film camera.

The memory card that comes with a camera usually has a low capacity, so you will want to buy extra memory cards as soon as possible. Depending on the size of the files you shoot (see File Formats, below), high-capacity memory cards can hold as many as 500 photographs. Carrying extra memory cards is like carrying extra film. If you plan to shoot RAW files or high-quality JPEG files, your memory cards will fill extremely fast.

## File formats

When you take a picture with your digital camera, it saves the image to the memory card, and you can later transfer your photos from the memory card to your computer. Most of the cameras available on the market today will save your images as JPEG files. Some higher-

end cameras allow you to capture images as RAW files, or to shoot both RAW files and JPEGs at the same time. A few allow you to save your photos as TIFF files. So what are all these file formats, and how do you decide which one to use (assuming your camera gives you the choice)? It really depends on what you intend to do with your images once you have processed them.

A *JPEG* is a compressed file in which some of the image's information has been discarded in order to reduce the file size. Although this sounds negative, most of the discarded information would not be visible to the eye. And unless you need to print very large photographs from your files, you probably don't need all that information. With a JPEG file, you'll be able to store many more images on your memory card, you'll be able to process your photographs faster, and they'll use much less space on your computer. You do have a choice of quality (high, medium, or low). Unless you shoot for the web only (including emailing photos), we recommend that you shoot at the highest-quality setting at all times. One drawback of the JPEG file format is that every time you open the file and alter the image, the file is compressed again when you save it as a JPEG. Therefore, once you've processed your JPEGs, you should save them as TIFF files to prevent them from losing more data.

A *RAW* file is an unaltered image containing all the data the sensor has captured. It's like a digital version of a negative or transparency. Should you shoot RAW files all the time? Well, it depends on how you are going to use your photographs and how much time you are willing to spend processing them. RAW files are extremely large. This means the number of images you can hold on one memory card is much less than when you shoot JPEGs. You'll need special software to open the files, you'll spend far more time processing the images, and your computer will need to have a lot of memory to store them. Unless you want to print very large photographs or are hoping to sell your images, you probably don't need to shoot RAW files. The JPEG format is sufficient for the needs of most amateur photographers.

A *TIFF* file is larger than either RAWS or JPEGs. Because of its size and the amount of time it takes to process, it is most popular as a format in which to save your images, because TIFF files don't lose any data through compression. Only a few cameras have TIFF as a digital image capture capability.

On my Canon cameras, I (André) am able to shoot RAW and JPEG files at the same time. This works well for me because I get a digital negative as well as a JPEG, which I can process quickly if I need to. Whether I'm shooting for a client or for myself, I want the best quality I can obtain, and that's why I paid a lot of money for top-of-the-line equipment. My stock agency also requires that I shoot in RAW. Because stock libraries often license images for huge print displays and billboards, they need RAW files because they contain all the information the sensor captured and will withstand much more adjustment than the JPEG format.

When I take snapshots or candids of friends at parties, or if I'm documenting the blooms in my garden, I usually shoot in high-quality JPEG format. I may shoot JPEG files when I experiment, perhaps panning or shooting blurs.

After processing my images, I always save them as TIFFs to prevent them from deteriorating further by compression when I open them to make adjustments.

## Computers and scanners

Digital photographs take up a lot of disk space, so before you start to transfer them to your computer, you'll want to make sure your computer has enough available disk space to store them. Depending on the age of your computer, you may be able to upgrade your RAM and hard drive. Or you may need to purchase a new computer with greater storage capacity. A professional computer salesperson will be able to help you determine the amount of RAM and hard drive size required for your photo storage needs.

You will also want a good-quality monitor. It's while looking at the monitor that you will be making adjustments to your images. If you are serious about printing your own photographs, and you like consistency in your work, a colour-management program may be a worthwhile investment. You will use this program to calibrate the colours on your monitor and your printer, so that what you print does not look completely different from what you saw on screen.

Photographers shooting film, and those of us with large inventories of images on film, can enjoy the benefits of digital photography by scanning negatives and transparencies and transferring them onto our computer. We can then use a photo processing program to work on our images. It is certainly a good introduction to the digital world. The price of scanners has come down considerably. Drum scanners offer optimum quality, but they are very expensive. Most photographers, both professionals and serious amateurs, opt for a good film scanner that can take both slides and negatives. A scanner capable of delivering an optical resolution between 3,000 and 4,000 ppi (pixels per inch) will produce good-quality prints up to around 12 × 18 inches

(30 × 46 cm). If you own a lot of prints, or like to shoot Polaroid film, flatbed scanners are relatively inexpensive and offer very good quality. I (André) recently scanned a 3-×-3-inch (8 × 8 cm) image on a Polaroid sx 70 using a flatbed scanner (which I paid less than $100 for) and enlarged it to 30 × 30 inches (45 × 45 cm), and the quality is incredible.

## Transferring your images

When your memory card is full, or when you want to look at your photographs, you can transfer directly from the camera to your computer using the port cable supplied with your camera. You can also purchase a card reader that connects to the USB port on your computer. All you need to do then is insert your memory card into the card reader. Once your images are transferred, you are ready to process them. Remember to reformat your memory card when you put it back into your camera. This will delete the images and free up the memory on the card.

## Processing your images

Unlike transparencies, digital photographs need some tweaking to achieve the best possible quality. Once you've transferred your images to your computer, you are ready to view and refine them using a photo processing program. How you open the files and process them will depend on whether you are working on a PC or a Mac and what photo processing program you are using. Your camera may have come packaged with photo processing software, or you may have to purchase the software. One of the best programs, used by many professional photographers, is PhotoShop. But there are lots of other programs out there, some of which are

much more user-friendly for the beginner. Explaining how to use these programs is beyond the scope of this book; each one is different and your best bet for learning how to use your software is to read the instructions that come with it, take the onscreen tutorial if one is available, and just play with it and experiment. As you become more familiar with what the software can do, your comfort level will grow.

Before you make any changes at all, it's a good idea to save your image as it is. That way, if you make any mistakes as you process the image, you can go back to the original and start again. You can also process one image in more than one way, achieving different effects and saving them in different files. And, with the continuing advances in digital imaging, you may want to process your images differently in two years' time.

Once you've opened an image and it appears onscreen, look at it carefully, assessing what can be done to improve its quality. You will be able to use your software to adjust brightness, contrast, colour, saturation, hue, and sharpness. Some programs give you the option of enhancing the quality of your photo with automatic adjustments to brightness, contrast, sharpness, or colour, or all of these at once. The program decides for you what needs to be done to improve the image and makes the adjustments with one click of the mouse. It's always worthwhile to try the automatic fixes and see if you are happy with the results. If you aren't, you can always click Undo and make the adjustments manually. You'll have to experiment for a while to get the hang of making manual changes to your images, but you'll have much more control over the results once you do. Always be careful not to overdo it: you don't want to end up with an unnatural-looking photograph.

Here are some examples of other types of adjustments you will be able to make using photo processing software:

**Rotating and cropping.** First, you might want to rotate your image. Say, for example, you used your camera to shoot a portrait rather than a landscape image. Your photo might appear sideways onscreen, but your program will allow you to rotate it to the proper orientation. Some programs will allow you to rotate images only in 90-degree increments, while others will let you make more subtle adjustments, perhaps to level a horizontal or vertical line (such as the horizon).

Next you might wish to crop the image. As with using a film camera, you may have captured more of the scene on the edges of your photograph than you intended when you composed the image using the viewfinder. Or you might find when you see the photograph onscreen that the composition isn't all that you had hoped for. You can often improve the composition of an image by cropping it. Using the mouse, select the portion of the photo you wish to keep. The program will then eliminate the portions outside the selected area. If you cut out more than you intended, you can click Undo and try again.

Sometimes a photograph as a whole isn't up to snuff, but a portion of it is excellent. For instance, say you have taken a group photo. Some of the people in the group have their eyes closed, while others have strained expressions. However, one person looks great. You can crop the picture down to a head-and-shoulders portrait of that one person. You may not have gotten the group shot you intended, but you

have ended up with a terrific individual portrait. This is a good example of why you should be cautious about deleting images before you view them onscreen.

**Touch-ups and removing unwanted elements.** Many programs will allow you to touch up people's faces. You can fix red eye, remove reflections from eyeglasses, and even cover up blemishes. In addition, you may be able to remove unwanted elements from your photographs, for example, a pole rising up through the middle of an otherwise scenic landscape. When covering up blemishes and other unwanted elements, always keep in mind that you are altering reality and are no longer preserving an accurate record of a moment in time. Be sure this is really what you want to do before you proceed.

**Removing noise.** As mentioned, "noise" is the term used for graininess on digital photos. You can use your software to reduce the dotted, grainy look of an image. You may also be able to reduce patterns of diagonal stripes, called "moiré," and remove coloured blocks that sometimes appear in JPEG images. As with all adjustments, be careful not to overdo it: you can lose some of the detail of your image in the process.

**Special effects.** In addition to converting colour photos to black-and-white, many programs will allow you to add special effects to your image. You might want to add a sepia tint to give your photo an old-fashioned look. You might give your photo the look of an impressionist painting or a charcoal drawing. You can distort the image, make it look like a negative, and add the appearance of texture, among many other options.

## Saving your images

Once you are happy with how your photograph appears, you are ready to save it. Name your image, and number it if you want. It can be useful to keep the original RAW or JPEG file number to facilitate retrieval of specific images. Remember that saving it as a JPEG will compress it, and it will lose a bit of information. It's a good idea to save photos as TIFFs or other lossless formats; from TIFFs you can convert to JPEG when you need to.

When you have many images on your computer, it is advisable to copy them to a CD-R or DVD. Digital images take up a lot of disk space and may slow your computer down. Saving to a removeable disk also ensures that you have a copy of your photographs if the hard drive on your computer should crash. For security measures, some photographers recommend burning two copies of the images you want to save. Better safe than sorry! It's also a good practice to burn all of your original, untouched images, and clearly indicate that the images are untouched on the CD-R or DVD. Keep burned CD-Rs and DVDs in their original containers and label these containers with the contents. This is an excellent way to file digital images.

If you are new to the digital world, this may all sound very confusing. Take your time, read your camera manual, experiment with your software, and practise, practise, practise. You may want to take a beginner's course on digital photography. Ideally, find someone who can teach you one on one, showing you how things work on your own camera and your own computer. It is well worth the investment.

# Film and film cameras

Some photographers prefer to use film only, but many others choose to use both film and digital capture. This is understandable. There is no single answer to which form of capture is better, as the final decision must depend on you, your amateur and professional interests, and your circumstances. Don't think of digital as a replacement for film, but rather as a more recently developed, second photographic medium for making visual images. You can use either medium or both.

## *Advantages of using film*

There are several advantages to using film. Perhaps the most obvious one is the fact that you don't have to spend the enormous amount of time at a computer that so many serious digital photographers do, especially people who are shooting primarily RAW files. If you already spend as much time at a computer as you want—or more than enough time—this freedom can be vital to both your physical and emotional well-being. But, if you do need a digital file, you can quickly scan your film image or have it scanned for you. (This is less of an

advantage if you are interested only in shooting JPEGs, are not very concerned about resolution, or regard photography purely as a casual recording medium.)

The second advantage of shooting film is cost. On balance, considering the costs of all the required equipment (hardware and software) of both mediums and the relative prices of this equipment, film is the less costly medium for really serious photographers, especially in getting yourself established. You will also have less equipment that is likely to need servicing.

The quality of films, especially transparency films, is generally superb.

At the time of writing, film beats digital files for long-term storage. Transparencies (made on good film and properly processed) that have been kept in average to low humidity remain in excellent condition for at least fifty years after they were made. Furthermore, they do not need to be regularly re-copied on new files with a potential loss of quality in the copying. Digital storage will undoubtedly improve as new technologies are developed, but with the rapid pace of change any

51

form of digital storage may become out of date in less time than film. And, keep in mind that your film images can always be scanned as digital files if and when you need them.

Also, if you are using film and want to make satisfying images, you must learn how to evaluate light and determine effective exposure. If you are shooting digital you do not need to do this (although it is easy enough with the more expensive cameras), as you can make exposure adjustments later on your computer. This may seem like an advantage for digital, but we do not regard it that way at all, as it leads to a lack of discipline that is critical to good seeing and image reproduction.

Learning good exposure, in our view, is a vital craft that should begin in the camera and, as required, carried to the computer. Careless initial exposure certainly means a great deal of extra work later on. The same is true for the design or composition of your images. Serious film workers learn to compose carefully; they do not expect to spend additional time correcting errors or careless designs on their computers.

Although it may seem strange to people who work entirely in digital, many film photographers prefer not seeing their images immediately. They actually appreciate the delay because they enjoy the anticipation that accompanies it. Also, they cannot instantly reject images. The delay means that, often by the time they view their images, they have a degree of distance from the moment of creation that allows them to make wiser choices in editing.

## Choosing films

Some photographers seem to think that selecting film is like choosing a partner. In fact, some photographers seem more committed to a particular film than they are to their spouse. However, no film is perfect. All colour and all black-and-white films have certain characteristics that make them excellent choices for some circumstances, and not so good for others. You can learn a lot about films by reading test reports in popular photographic magazines and trade publications, but you'll never know a film well until you have used it with your own lenses in a variety of situations. No matter how much you read, you can't tell whether you'll like a new model of car until you drive it.

A serious photographer will make fairly regular comparison tests with different films, not just to learn about them initially, but also to develop and retain a feeling about them. There's a very easy way to do this. If, let's say, you're finishing off a roll of brand A, leave the camera in position on the tripod as you reload with a roll of brand B. Repeat the last shot on the new roll. You'll only have two photographs for comparison, but the differences may be obvious. If you perform this simple test with various films on a fairly frequent basis, you'll soon have a pretty good collection of comparative material, and you'll find yourself developing a kind of intuitive knowledge of which film is the best choice for the situation in which you're working.

Remember that manufacturers are continually improving their products, so just because you didn't think much of a particular film two years ago is no reason to ignore it forever. Keep your testing up-to-date. Of course, the quality of a negative or transparency also depends on the quality of the processing, so it certainly helps to do your own developing (provided you're good at it), or to send your test films to a laboratory that maintains strict quality control.

What should you look for in evaluating films? That's a very basic question, but one that we can answer only in part, because every photographer's interests and perceptions differ. All we can do is list objective factors that can be tested. It will be up to you to evaluate the results, according to your personal tastes.

## Colour or black-and-white (standard and chromogenic)

First, you should consider the most fundamental of all questions about films: which is the better for your photographic image, colour or black-and-white? While the final answer to this question must be subjective, there is a major objective difference to consider. *The most important element in a black-and-white image is the range of tones or light values, that is, brightness. The most important element in a colour image is colour*, although the range of tones may also be very important.

The implications of this difference are wide-ranging; let me describe a few practical effects. In a black-and-white portrait, the viewer's attention will be drawn to the model's eyes. In a colour portrait, the viewer's attention will often go to the person's lips or clothes. For this reason, consider black-and-white film seriously for making portraits. Colour is frequently unnecessary, and often distracting. But with autumn leaves or sunsets, it's usually colour that catches the photographer's eye, so black-and-white film would be an unlikely choice.

Not all circumstances allow for such an easy decision. In fact, most don't. So, let's consider a less definite situation, such as a winter landscape with just two subjects in it—an expanse of snow and a row of barren trees. Recently, we saw two versions of such a scene,

one in black and white and one in colour. The decision about which film should be used was made, in each case, on subjective grounds. One of the photographers responds more strongly to forms than to colours, and she knew that black-and-white film would intensify the shapes, lines, and textures by eliminating any attention that might be paid to colour, even though the colour saturation was very weak.

The other photographer chose colour because his main emotional response was to the colour. He was struck by the starkness of the trees against the snow, but the warm colour of early twilight softened the harshness for him. He decided to record the bleakness and the gentleness in one image—to show that the contrast of impressions produced its own harmony. Both photographers were successful in expressing their emotional response to this winter landscape.

Choosing between colour and black-and-white seems to be a natural process for most film photographers. But you should try to analyze your choice and also familiarize yourself with the different characteristics of the films.

If you like shooting black-and-white film and do not own or have access to a darkroom, black-and-white chromogenic film may be useful for you because you can have it processed anywhere that colour film is processed.

## Characteristics of films

Let's look at the objective characteristics by which films can be evaluated, and what these may mean to your photography.

*Brilliance* is an important consideration when you select colour films. Extensive comparison tests we have

conducted with two colour films proved that, on my equipment, one brand of film always rendered hues more brilliantly than the other. Since I (Freeman) usually prefer muted colours, I will avoid using this film except when the colours in my subject are, to begin with, somewhat more muted than I want. But, if I want to be certain of a strong, dramatic rendition of hues, I'll choose the film that regularly produces it, which is the film I (André) usually prefer.

When it comes to *colour* itself, opinions may differ. Not everybody agrees on what is normal or natural colour. Human response to colour is conditioned by both physical and psychological factors. You are the only one who can determine which films will render the various hues more accurately for you in different situations. When you want to photograph people with colour film, consider using a film that renders neutral colours well (not highly saturated), as the skin tones will appear to be more natural.

*Speed* is the measure of a film's sensitivity to light. Some films respond to light more quickly than others. A film with a low sensitivity to light is known as a "slow" film, one with high sensitivity is known as a "fast" film. The speed of a film is indicated (both on the card board box and on the film cassette itself) in the form of an exposure index or ISO rating. A film with an ISO rating of 50 is considered slow; from 100 to 200 are medium; and 400 ISO or higher is regarded as fast.

You should choose a high-speed film when you want to freeze action, such as a runner crossing the finish line, or when you want to photograph in low light, but don't have a tripod with you. Choose a slow film when you want to be sure of making long exposures. For instance, it's much easier to give a sense of movement in water, or blur in wind-tossed flowers, if you can shoot at $\frac{1}{8}$ second instead of at $\frac{1}{125}$ second under a given intensity of light.

The colours rendered by a film should be the same for all exposure times and light intensities. This is the law of reciprocity. But if exposure times are very long or very short, or if light intensities are very high or very low, the law of reciprocity fails. Different films react in different ways to reciprocity failure. The colour balance of a film can change, and the resulting image may have an overall colour cast.

The effect of changes in shutter speeds on the way films reproduce colours is barely noticeable between the middle speeds of $\frac{1}{250}$ to $\frac{1}{30}$ second, may be slightly noticeable between $\frac{1}{500}$ or $\frac{1}{15}$ to $\frac{1}{8}$ second, and can be easy to see after that. The effect is sometimes pronounced with time exposures.

If you want to change the colours in your picture, choose a slow film for a dark situation, so you'll be forced into long exposures. We're speaking here of exposures of a second or more, the longer the exposure time, the more likely it will show the colour shift. For example, it's our experience (given the films' characteristics as we write this) that some daylight films will become "warmer" the longer they are exposed, but that others will not. So, if we're in dark woods photographing a white mushroom surrounded by green moss, we may choose brand X to avoid the accentuated greens and blues that brand Y could produce. It must be emphasized, however, that the characteristics of films are continually being tested by the manufacturers and improvements are being made regularly. It's quite possible that the responses of particular films will be changed. The important thing is to remember that

colour shifts may occur, and to make your own tests with current film stock.

High-speed colour films, which tend to give somewhat less colour brilliance at any time, lose both brilliance and contrast more swiftly in long exposures than slower-speed films. So, to mute existing colours, choose a high-speed film, and make the longest exposure you can.

*Gradation* is the term used to describe a film's ability to reproduce contrast or a range of dark, light, and intermediate tones. (This subject is also discussed in "Properties of light," pages 60 to 61, and "Directions of light," pages 62 to 66.) It's an important measure for both black-and-white and colour films, but especially the former.

In high-contrast film the transition between different tones tends to be abrupt. In other words, there is a strong tendency to lights and darks, and a de-emphasis of middle tones. A low-contrast film performs in the opposite way, emphasizing the middle tones and softening the lightest and darkest areas. A medium-contrast film produces negatives or transparencies with no emphasis on any particular part of the range of tones; it will give good solid dark and light tones and a wide range of intermediate tones. Consequently, medium-contrast films are the most useful films for most photographers most of the time. A film's ability to reproduce contrast is related to its speed. Slow-speed films generally produce the greatest contrast, and high-speed films the least. Any black-and-white film will produce more contrast if the negative is underexposed and overdeveloped, and less contrast if it is overexposed and underdeveloped.

The *latitude* of a film is its ability to tolerate overexposure and underexposure, and still produce an acceptable image. Most films are very tolerant of overexposure and underexposure, but colour films have less latitude than black-and-white ones. They still produce acceptable exposures (depending on the subject matter and lighting) when underexposed up to three stops, or when overexposed up to two stops. But this is a subjective evaluation, and you may want to stretch the limits under certain conditions. Latitude is also related to film speed. In general, slow-speed films have more latitude than fast ones.

Films have a granular structure or *graininess*. This is caused by the irregular distribution and overlapping of silver-bromide crystals, which reproduce grey tones as tiny, separate dots. The larger the crystals, the more graininess will be apparent. Fast films have larger crystals than slow films.

The visual effects of grain are very important to consider when selecting black-and-white films. To begin with, all black-and-white negatives, potentially, will end up as prints, and not much enlargement is required before the grain structure of a film starts to show. Select a high-speed film if you want a lot of grain, and intensify it through overexposure and overdevelopment. If you don't want grain, select a very slow-speed film, and develop the film normally.

Grain is of little importance to the average amateur who shoots colour slides, because projector lenses and screen surfaces reduce the appearance of grain. In normal projection of slides, nobody will ever notice it. However, the presence or absence of grain is of much greater importance to photographers who want fine enlargements from colour slides or colour negatives.

All films have certain objective characteristics to which the photographer will respond subjectively. This

is why it's essential to depend less on manufacturers' reports and other photographers' evaluations, and more on your own tests made with your own equipment. See for yourself, feel for yourself, and judge for yourself. In choosing film, as in practically every other facet of photography, you should not deny yourself the pleasure of discovery and the satisfaction of personal experience.

# LEARNING TO SEE

# Discipline

Fine images don't happen—they are made! And made very, very carefully. Good photographers are careful people. They're disciplined. Using a tripod is an excellent discipline. It induces the care and allows for the precision in composition that distinguishes most good photographs.

Both of us still use a tripod for making most of our photographs, but even when we don't, we think as if we were. We react in the same way. It's second nature now. Once you've learned how, you never forget. But this is not about tripods; we've talked about them already. Rather, it's about being thoughtful and deliberate, about taking time to consider all the details which will affect your final exposure.

Let's give you an example. Behind my (Freeman's) house there's a meadow that changes dramatically with the seasons. If I go out on a dew-drenched summer morning to watch the first rays of sunlight streaming through the daisies and the wild roses, I will probably become euphoric. And, if I decide to photograph the meadow, I will make certain that my subjective response plays a fundamental part in how I go about making pictures. In fact, it's really both the scene and my subjective response that I'll want to capture.

So, chances are that one thing I will do is carefully consider deliberate use of overexposure to lighten colours and to intensify the whites of the rising mists and the silver of the sun's rays. I want to record and to convey lightness, delicacy, and gentleness, not only because the scene shows me these things, but also because I feel them. In fact, many people respond to light tones and gentle colours with feelings of delicacy and ease, and often with a sense of exhilaration.

If I go into the same field in the slanting sunlight of a November afternoon, when the brown grasses are etched upon the meadow in a sort of military progression, when they are stiffened into a rigidity that no super-starch could ever produce, my response and my instructions to the camera will be quite different.

Gone is my euphoria. Gone is my exhilaration. Now my fascination is with symmetry and shape, with line and form. As I look at the individual stalks of grass, I

notice that every one is illuminated brightly on the south and darkened by shadow on the north. So, I stand to the east or west in order to see both light and dark, and choose an exposure which will retain the highlights but let the shadows go very black. I want the sharp tonal distinctions. I need the contrast. To get this, I will give slightly less exposure than what the meter indicates is the "correct" reading. The choice is mine, and I make it on the basis of how the subject matter appears to me, and how I feel about it.

Fine images depend upon thinking about what you see and understanding what you feel about what you see. Fine images demand careful preparation. The more careful you are when you begin photography, the easier you'll find it later on. There are no shortcuts. And there is no greater pleasure in photography than achieving the image you set out to capture or create.

# Properties of light

Light has three characteristics that photographers must understand. These are brightness, quality, and colour. They have a major bearing on how and what people see and feel. Sudden differences in brightness or quality of light, and changes in colour, can rapidly alter a person's mood. All three characteristics have strong symbolic value as well.

Being aware of the human response to these characteristics of light is just as important to a photographer as knowing the amount of light required to make an exposure on film. In some respects it's more important, because it's easier to calculate the quantity of light needed for a good exposure than it is to understand why people respond to light as they do. The control of light is fundamental to all photography, whether black-and-white or colour. Let's consider the three characteristics of light in turn.

*Brightness* is the measure of the intensity of light. A pure black object reflects no light at all. A pure white object reflects all the light that strikes it. Between the two lies a continuum of grey tones—from almost pure black to almost pure white. This continuum or range of tones is subject to constant scrutiny by photographers who work in black-and-white. Unfortunately, colour photographers often pay it too little attention, even though it is also very important in making satisfactory colour images.

All photographers must consider carefully the various tones within the picture area. They must decide the amount of light tones they want in comparison to the amount of middle or dark tones. They must be aware of small isolated areas of a particular tone that will become accent points.

One of the best exercises for a beginning photographer is to study a scene or object, and translate all colours into shades of light and dark—to see the picture entirely in terms of its areas of brightness. Objects are not merely red or green or blue. They are also light and dark and in between in infinite gradations. Effective visual statement depends on the photographer's ability to recognize these distinctions, because recognizing them makes controlling them possible.

Colour photographers should be aware of two basic facts about tonal range. 1/ If an image has a limited range of colours, it must have an extended range of tones, or contrast of tones, for composition to occur. 2/ If an image has a limited range of tones, it must have an extended range of colours, or contrast of colours, for composition to occur. In other words, design is impossible in an image that is restricted to one colour and one tone. The photographs on pages 150, 151, and 153 illustrate these basic facts.

The *quality* of light has to do with its harshness or softness. Direct or harsh light emanates from a point-like source, like the sun or a light bulb, and tends to accentuate tonal differences or contrasts. Soft or indirect light occurs when the source of illumination is obscured and light is diffused before it reflects off the subject. Cloudy days give soft light, because the clouds prevent sunlight from reaching us directly. Clouds diffuse light, as does a canopy of leaves, or a flash which is "bounced" off a ceiling rather than being aimed directly at the subject. The quality of light has a strong bearing on the mood of a picture.

Under harsh light, tonal differences are abrupt, and contrasts appear stronger. Under soft light, tonal differences are seldom abrupt, and brightness shades gradually from light to dark. Contrast is less definite, although usually the extremes of brightness are still there, at least to the trained eye. Under soft light the intermediate tones are increased and play a greater role in composition.

The third important characteristic of light is *colour*. The colour of daylight varies enormously between dawn and dusk. In most cases, photographers accept these variations and appreciate them. Who, for example, would want to filter the gold out of a sunset? Of course, different kinds of artificial illumination affect the way films reproduce colour, and film photographers quite often use certain films or filters that correct the colour for "normal" perception by the human eye. Digital photographers can accomplish the same goal using image processing software, or to some degree by adjusting the white balance setting on their camera.

The basic problem facing a photographer is not to obtain accurate colour, but rather to produce colour that is appropriate to the subject or to his feeling about it. For example, if a person's face appears slightly green, because she is standing in the reflected light of a green building, the photographer will want to correct it. On the other hand, a blue cast on ice and snow adds to the feeling of chill, and is probably acceptable.

Photographers should try to make use of the symbolic values and psychological effects of the three properties of light—brightness, quality, and colour. There's no doubt that a bright day affects us differently from a dark day. Similarly, we feel differently at twilight than we do at dawn, and it's not just because we've worked all day. The presence or absence of light, or more accurately, the presence or absence of tones within a picture, and the relative amounts of those tones that are present all play important roles in our emotional response.

Photographers must constantly assess both the light they need for exposing and the effect that light will have on viewers of the completed image.

# Directions of light

Each angle of lighting creates specific visual effects or opportunities, and each causes special problems. One of the great pleasures of making pictures, or of just using your eyes well at any time, is in observing the direction in which light falls and the effect this has on the subject.

## Direct lighting

There are, basically, three directions from which direct light can fall on your subject: on the front, on the side (one side or other), or on the back. These directions of light are called, simply, front lighting, side lighting, and backlighting. Each direction tends to produce certain visual and emotional effects, so each has advantages and disadvantages. Before you think about exposure, you must recognize the direction of the light you're dealing with.

*Front lighting* occurs when the sun is behind you and the light from it is falling directly on the subject in front of your camera, as in the photographs on pages 128 and 129. This is the kind of lighting beginners in photography feel most comfortable with, usually as a result of being told, "Make sure the sun is over your shoulder!" It's also the kind of lighting you get when you point a flash gun directly at your subject.

Front lighting can produce dramatic results, especially if the main subject is lighter than its surroundings, like a clump of birches standing at the edge of an evergreen forest. The sun streaming down on the forest is reflected back strongly from the birches, but not from the spruces and hemlocks. So the clump of birches stands out from the rest of the trees. In a situation like this, the effect of front lighting commands your attention. It's the reason for your picture. If the sun had not been shining or had been shining from any other direction, you might not have noticed the birches at all.

However, front lighting is often the least interesting form of lighting, simply because the shadows which your subject casts fall behind it. This means that the lines and dark tones of the shadows are eliminated from your composition, so it will have less visual variety. If you have no shadows, then you must make sure that the

space surrounding your centre of interest is well used in other ways.

*Side lighting* occurs when your light source is to one side or other of the picture area and the shadows are falling across it, as in the photograph on page 20. (Light streaming in from a corner is usually referred to as side lighting as well—as in the photo on page 131—although technically it's halfway between side lighting and backlighting, or side lighting and front lighting.) Side lighting is exciting because 1/ the shadows contain deep tones that contrast with the highlights of the image; 2/ the shadows appear as lines of varying thickness and become important visual elements in their own right; 3/ these shadows give the impression of a third dimension; and 4/ textures tend to be emphasized. A photographer should capitalize on these assets.

Some of the most pleasant side lighting occurs early or late in the day when shadows are long and the light itself is warm. The direction and length of shadows and the colour of light at these times of day tend to produce a richness of colour and tones which is difficult to explain, but easy to see. People like it, and photographers tend to become more active as afternoon wears on toward evening.

One problem with side lighting may be an excess of exciting tones that create too many lines and shapes. There's almost too much on the plate. So, be selective. You will have to sort out the elements with your eye, and unless you're looking for a richly tapestried effect, start to eliminate things that will simply clutter your picture. Whether you're photographing a city street, a sweeping mountain landscape, or a few square centimetres of a meadow, the problem is the same. Suggest more by saying less. Six or seven strong bars caused by alternating lines of sun and shadow will probably be more effective than fifty—most of the time. You can make successful pictures that contain a lot of shadows, but you should be careful in each case to include little else, so the design is not destroyed.

*Backlighting* occurs when you are facing the sun. The light is now falling on the back of your subject, and often produces eye-catching highlights (as in the photographs on pages 67 and 99), halos, and silhouettes. It's strong and dramatic, because it usually causes abrupt and extreme tonal changes. Where whites stop, blacks often begin with little or no intermediate tone.

Backlighting makes real demands on a photographer. Good composition is often far from easy, and the best exposure may be difficult to determine and even harder to achieve. But don't let these minor annoyances stop you. Treat back lighting the same way you must treat every photographic situation. Use its advantages. Play on its strengths!

What are these advantages? 1/ The sharp delineation of forms; 2/ the creation of bold light and dark tones, with a reduction of detail in shadow areas; and 3/ a greater sense of depth, because shadows are falling from the background toward the foreground. Backlighting simplifies and strengthens design, and helps to produce strong graphic images.

Backlighting creates a heightened sense of the visually dramatic, and this in turn produces strong human emotional response. Anybody putting a slide show together should consider placing excellent backlighted photographs at critical points in the sequence, especially after a series of softer, more gentle images. But do it sparingly. A little well-spaced drama is better than a constant diet.

There are problems in using backlighting to compose photographs. Sometimes you get too much black throughout the picture space, or too much black in one area, or annoying things such as straight black lines (tree trunks, perhaps) rising out of unrelated forms (a rather round boulder, for example). In order to avoid these graphic conflicts, or at least to reduce them as much as possible, you will have to position your camera with care. That may be difficult to do if the sun is streaming into your lens. If it is, stop your lens down to f/16 or f/22 and press the depth-of-field preview button to darken the image and make viewing easier.

Don't worry about pointing your lens directly at the sun. With today's single-lens reflex cameras nothing will happen to the camera or its shutter or lens. However, be careful of your eyes. Stop the lens down to f/16 or f/22, press the depth-of-field preview button, and don't gaze too long into the sun when making your composition.

A common question about backlighting is "How do I get rid of lens flare?" Sometimes, by carefully tilting the camera up or down, or to the left or right, lens flare will disappear. Your composition will be altered, but probably not so severely that you will have to abandon it. Also, by using a lens hood or your hand to shield the front of your lens, you may be able to eliminate flare without altering your composition. You can, of course, learn to live with lens flare. If you start to think of it as an asset, you're playing a whole new ball game with the sun.

Backlighted situations can produce difficulties in determining exposure. The whole topic of exposure comes later, but it's necessary to talk about it here.

There's a rule of thumb that says, in backlighted situations you follow what your meter tells you and then open up one f/stop. If you're getting a reading of $\frac{1}{250}$ second at f/16, try $\frac{1}{250}$ second at f/11 instead, or use $\frac{1}{125}$ second at f/16 if you don't want to lose any depth of field. This formula assumes that every photographer wants some detail in the shadow areas of every back-lighted composition he makes.

Of course, there are exceptions. At sunset, for instance, some photographers like to close down half an f/stop from the meter reading in order to deepen the richness of colours in the sky. If the meter says $\frac{1}{60}$ second at f/8, they will go to $\frac{1}{60}$ second between f/8 and f/11. Other photographers find the tones and colour saturation seem too "heavy" if they do this. So what it comes down to is that you have to make up your own mind about what you want your final image to look like.

Before you even put your camera on your tripod you may want to approach your subject and take some sample light readings. What does your meter say about the dark side of the big rock? What is it telling you when you point it at the grass? What is the exposure of the sky when the sun is slightly obscured by the branches of a tree? And so on. What you're looking for is a *range* of tones or light values, particularly the values of the most important elements in your composition. Make a mental note of them, then go back to your camera, compose your picture, and determine the depth of field you want. After these things are done, you can choose the overall exposure you want. It's always the last thing you should do before you trip the shutter release.

How do you choose? If the sun is unclouded, bright, fairly high in the sky, and shining directly into the lens, $\frac{1}{250}$ second or $\frac{1}{500}$ second at f/16 will work every time with ISO 100. You'll choose the slower shutter speed if

you want a slightly lighter blue in the sky and a little more detail in the landforms. You'll choose the faster speed if you want to produce bold colours and tones, and a strong sense of the dramatic. In either case it's doubtful that your picture will be successful if all the bright is in the sky and all the dark is in the land. Try to be observant and thoughtful enough to include secondary highlights in the dark areas in order to give balance to your composition—ripples of light on water, a halo of white fuzz around a leaf, or an icy roadway in the foreground. With many lenses, shooting directly at the sun will also give a star effect, if the lens is set at the smallest aperture.

Most backlighted compositions do not include the light source, but they often have strong highlights in them and strong blacks as well. The whites can only get so white, as you admit more light through the lens. There is nothing whiter than white; so as you open up your lens you are not making the whites whiter. You are making the greys lighter and turning black into greys. That may be desirable—or it may not.

Conversely, there is nothing blacker than black. So when you progressively reduce the amount of light, you are making the highlights and grey tones darker, not the blacks. Therefore, you don't have to be extravagant in overexposing or underexposing to get significant changes of effect.

Let's take an example. Say your light meter is telling you that $1/125$ second at f/8 is the average exposure for the collected items in your composition, but you want, above all else, to capture the sunlit white wool forming a halo around a sheep. If you don't care about the other details all you have to do is close down your lens enough to render all the grey tones black. With both digital capture and colour film that probably will take two or three stops, so you will end up with a setting of either f/16 or f/22. The white won't be as white as it would have been if you had used f/8. But remember, since you have now eliminated all the grey tones by making them black, the rim of light on the wool has nothing to compete with for attention. In relation to the rest of the picture, the contrast has actually been increased, and the outline of the sheep will stand out dramatically. If you are using black-and-white film, choose one that produces good contrast, follow these general guidelines for colour, and make adjustments in your printing.

If you choose to reverse the procedure, the same principles apply—in reverse. Let's say that you are trying to produce an image that is delicate, airy, and light, perhaps a dewdrop sparkling on a blade of grass with the morning sun rising behind it, but the backlighted grasses appear too dark, and they conflict with your feelings about the subject. So you need to lighten the dark tones a bit. No problem. If your meter is indicating $1/1000$ second at f/4, you merely admit more light than the meter suggests, say $1/500$ second at f/4. The increase in light may affect (desaturate) the colour of the sun a little, but the real effect will be on the darker tones. The sun can't get much whiter, but the grasses can certainly become less dark.

Whites, greys, blacks, light values, and exposure meters all raise again the question of tonal range. Learning to recognize differences of tone is fundamental for every photographer. Often colour photographers don't pay nearly enough attention to tone, but it's just as important as colour itself.

## Indirect lighting

For me, no form of illumination is more pleasing than diffused or indirect lighting. Fog, rain, clouds, and mist should not be dismissed as visual impediments, but understood as assets in the seeing and making of fine images. They don't restrict the photographer; they offer new and challenging opportunities.

Colours are richer and subtle variations of hue are more apparent on cloudy days than they are in sunshine. Best of all, there is a continuous range of tones from white to black. Gone are the searing contrasts of impenetrable blacks and scorching highlights. The blacks are still there, but reduced; the highlights are still there, but softened. If you examine a dead branch on a cloudy day, you will see that the upper side is much lighter than the underside. Light is diffused, but it still has direction, and there is plenty of contrast. The photographs on pages 70, 94, and 134 are three of many photographs in this book that are taken with indirect lighting.

If you are photographing people in soft light (see page 148), you won't have to contend with "hot spots" on their foreheads or with dark chasms where their eyes should be. You won't need fill-in flash to even up the tones. Skin colours will appear to be natural. You'll be able to photograph children playing or running, and use a slow shutter speed to give a sense of motion, instead of freezing the action. You'll be able to swing or pan your camera during a horse race and capture the frenzy—not the arrested movement of a sunny day when you're forced to use either a fast shutter speed or a neutral density filter to cut down on the amount of light.

Many nature photographs are not only made more easily, but also appear more appealing and authentic when shot under diffused light. Certainly this is true with wildflowers. Colours seem to glow, hues blend gently, and glaring highlights are absent. If you see a wildflower that you want to photograph, but the sun is shining, try providing your own diffused or indirect light by shading the plant with your body. Shoot it both ways and compare the two.

We are not suggesting that all wildflowers must be photographed in soft light, because every photographic situation should be assessed on its own merits, but we strongly recommend this light for them. Direct lighting is far more likely to impose a dramatic pictorial effect, which may have little or nothing to do with the blossom itself. Also, the colour range is reduced in sunlight, or when you use direct flash without any reflectors to bounce light around and diffuse it. What is sensible practice when choosing light for wildflowers is even more sensible for mushrooms, a favourite subject of many nature photographers. Because many fungi prefer dark or shady places, the use of flash or strong sunlight may suggest a lack of authenticity.

Not all pictures of nature subjects are meant to be authentic nature photographs. Indeed, many are not. Objects in nature have always had strong symbolic values for people, and photographers may choose whatever lighting situations or other controls they want in order to strengthen the subjective statement they wish to make. Yet, even here, diffused lighting is a useful tool. No matter how selective or austere you may be in your composition, complex subtleties of tone and colour can be caught only in diffused light, and these are often powerful symbols in their own right.

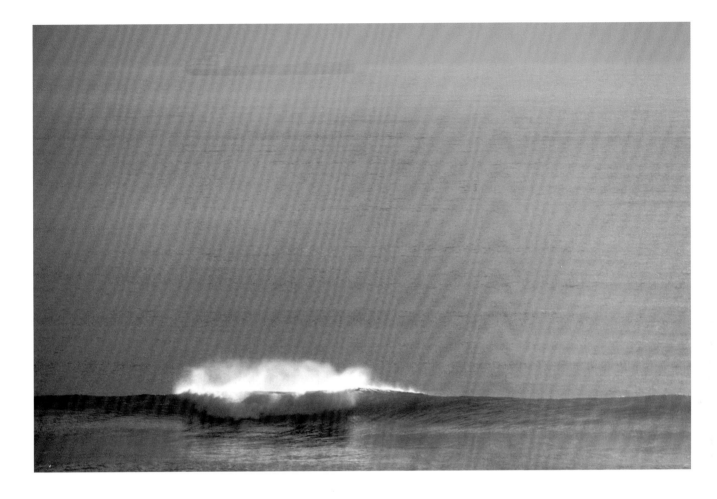

Surfers wait for the perfect wave—and remember it forever. So do photographers, who can preserve visually the fleeting moment of ecstasy. But it isn't easy. Everything depends, first of all, on the water and the wind, and it definitely depends on the light. You must anticipate when these natural elements may combine magnificently, be on location, and prepare by checking camera settings and possible compositions. Then you must observe patiently, seemingly forever, until an instant response is required. And then you hope! (*FP*)

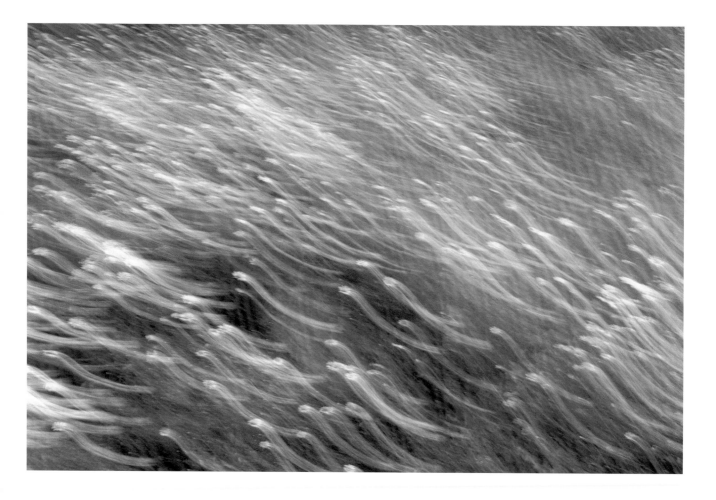

Panning usually refers to using a slow shutter speed (say, $\frac{1}{4}$ or $\frac{1}{8}$ second) while following a moving object with your camera at the same apparent speed. When you press the shutter release, the moving object appears sharp, but the surroundings are blurred. This contrast conveys a sense of motion. However, you can "pan" on any scene; you don't "need" a moving object. Here is what I did in a part of my garden filled with white daisies and a few red poppies. (*FP*)

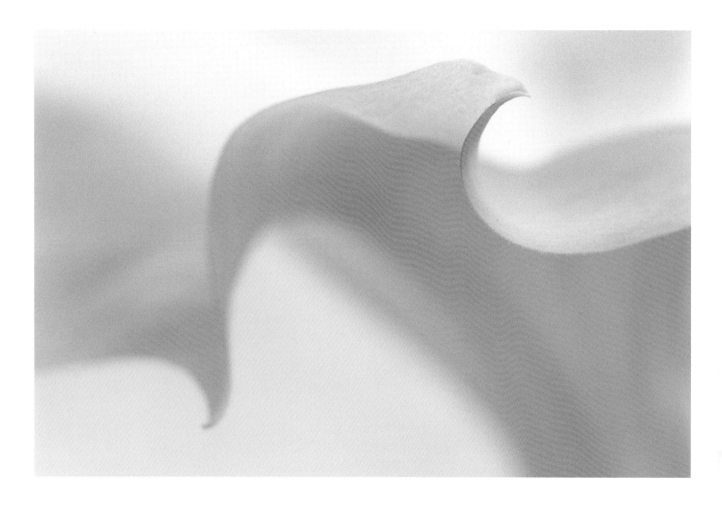

All my life I have felt close to the plant world, so I have a greenhouse/sunroom attached to my house that provides me with emotional sustenance during the long, cold Canadian winter. I garden and make photographs here. Both activities are highly visual. After I composed this quite abstract close-up of a Jimson Weed, or Moonflower, I read my meter (to determine middle grey) and then overexposed by one shutter speed in order to keep the tones light. (*FP*)

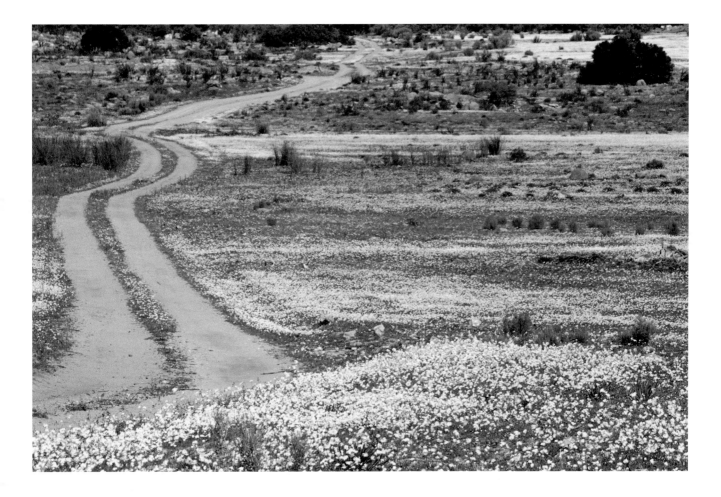

To discover these wildflowers was an unexpected thrill! I felt that somehow they were blooming for me, and that if I didn't photograph them, their supreme act of beauty would be lost once they had finished their short period of bloom. I feel the same way about visual images. All around me all the time are pictures waiting to be discovered. Making a photograph is the act of giving permanence to something transient. It's making sure the wildflowers will never go away. (*FP*)

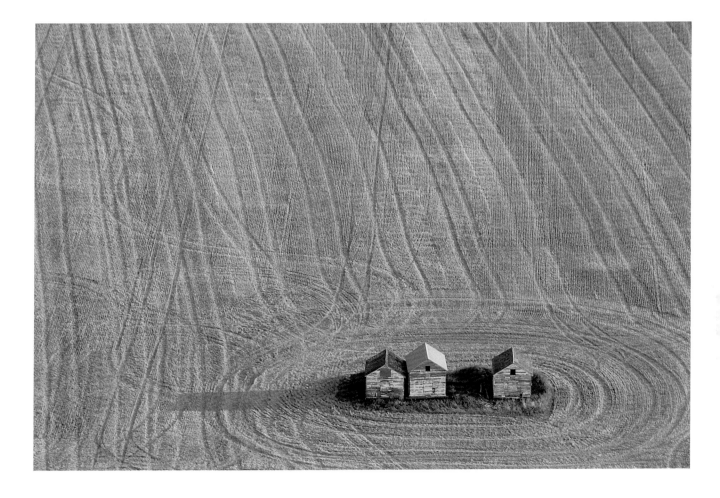

In Regina, Saskatchewan, September is harvest time. I imagined that the fields would look amazing from a high vantage point, so I chartered a plane and took to the air for the joy of it. A digital camera was an obvious choice: I could change the ISO if I needed to, and I would not have to reload film (not always the easiest thing to do on a small aircraft with the passenger door removed). I set the camera to shoot high-quality JPEGs. The memory card in my camera held over five hundred photographs—more than enough for my time up in the sky. I was pleased with many of the images I shot that day, and with their quality. (AG)

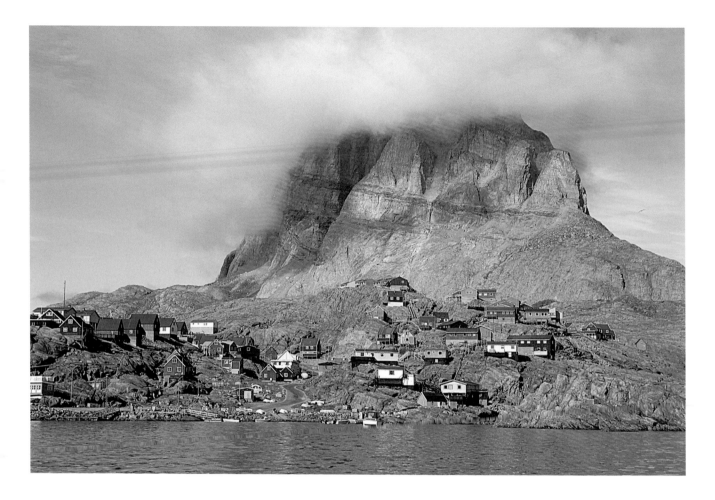

Ummanaq, Greenland is a tiny village in a dramatic setting on the coast of Greenland. After exploring the small community, I headed back to our ship on a zodiac. As I photographed this scene of clouds above the rugged mountain, I made sure to capture the shadows the clouds cast. I included some water in the image to indicate the coastal setting. (AG)

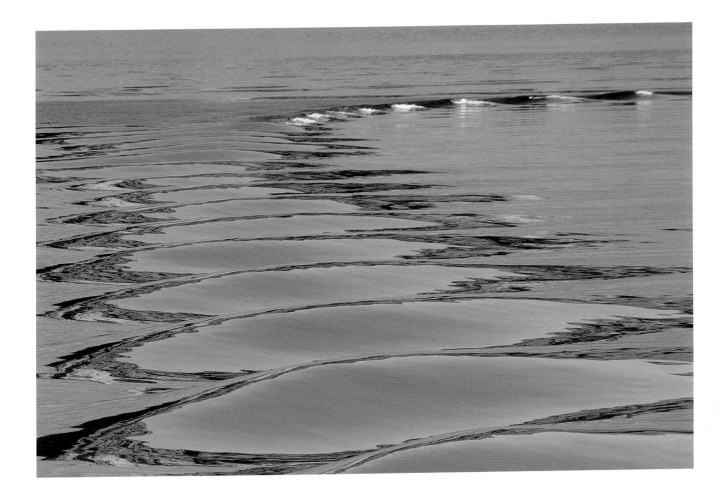

On a recent expedition to the Canadian arctic, I took most of my images with a digital camera. It was satisfying to view the photographs instantly on the LCD screen and to process them when I had some free time on the trip. It was also exciting to share some of the images with my fellow travellers. Adventure Canada's *MS Explorer* created this simple, sensuous curving line in its wake. (AG)

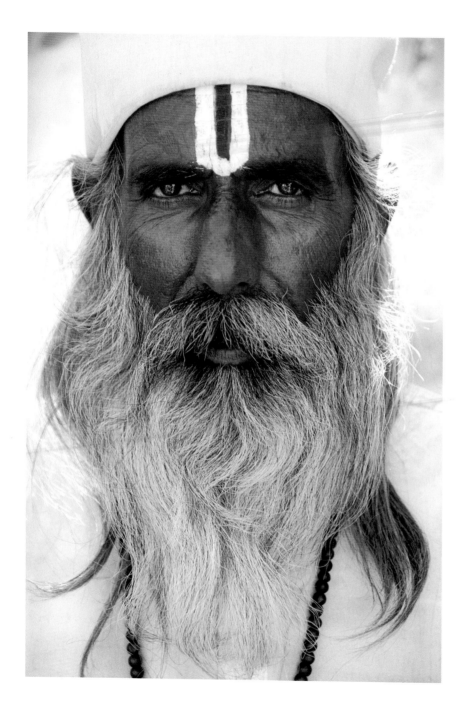

While visiting a temple in Udaipur, India, I noticed this sadhu sitting on the steps. I suspected that with a small donation he would agree to pose for me, which he did. The tight crop of his face eliminated the distractions in the background, and his white clothes helped to emphasize the character of his face and the powerful look in his eyes. A large smile formed on his face when I showed him the portrait I'd taken of him on the LCD screen on the back of my digital camera. (AG)

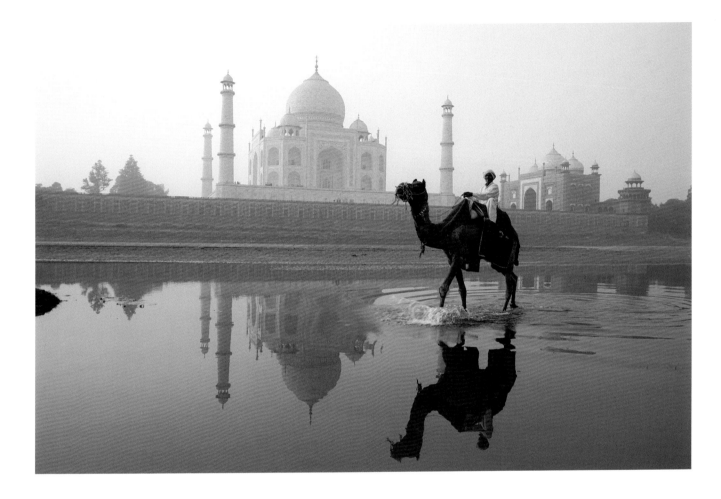

When travelling to India with a friend, I chose to bring only my digital camera. How liberating it was not to have to carry two hundred rolls of film! This particular morning started as a let-down. The sunrise wasn't spectacular, and part of the Taj Mahal was under repairs and scaffolded. My friend Karen arranged to photograph this man and camel, and I soon joined in. Under the softest of light, the reflection is disturbed by the camel in motion. Karen and the man on the camel draped in red made me very happy that day. (AG)

Two dark lines of lichen point powerfully down to a tiny patch of white flowers, which stops the visual movement. The relatively equal vertical spaces on either side of the lines give the composition balance. The triangular shape in the lower right relieves the formality. (*FP*)

The circle is the most visually and psychologically powerful of all shapes. In both nature and human creations it draws attention to itself strongly and focuses our attention. Symbolically, the circle represents the Self, centredness, and wholeness in every known culture. This composition shows a large, imperfect circle containing a smaller, more perfect one. The psychological implications of this reinforce the visual ones without us even realizing it. (*FP*)

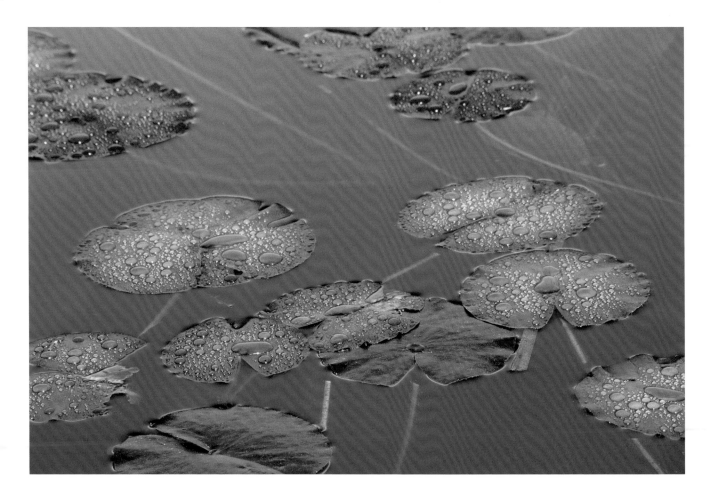

Every year I photograph the botanical garden in my hometown of Edmundston, New Brunswick. A garden constantly evolves, and so does a photographer. I could not resist these dew-covered lily pads. I composed my picture and chose the smallest aperture so everything would be in focus. When I'm moved by a scene like this one, I tend to bracket my exposures by half a stop from my assessed exposure; I can decide later which shot best reflects how I felt about the scene. (AG)

# Exposure

Exposing a picture correctly is nothing more than controlling accurately the amount of light which reaches the sensor or film during a given period of time. The only correct exposure for any subject is the exposure you want. Your light meter will be an invaluable guide in measuring the intensity of light and indicating basic exposure, but it can't measure your wishes. It can't tell how bright or how dark you want the final picture to appear, so once it has told you what it can, thank it kindly for the information and then make some common sense decisions.

## What can a light meter tell you?

Basically, only one thing. If it's a reflected-light meter (all meters built into digital and film cameras are of this type), you must point it at your subject matter; it measures the intensity of light reflected from that, and tells you the combinations of shutter speeds and lens openings that will give you middle grey—halfway between pure white and pure black. That's what it's built for. Nothing more!

Keep in mind that the light meter measures the light falling on the subject matter *in the area of your viewfinder that is sensitive to light*. That area may be the entire picture space, the centre, or only a spot of your choosing (let's say 2% of the picture space). These variations are described as spot, centre-weighted, and matrix metering (measuring several fixed points or a matrix). Many cameras allow you to switch between the various metering modes. Make sure you know what your camera does. (The instruction manual will tell you.)

Regardless of whether you are measuring the entire picture area or only some part of it, the meter is always recording the tones (degrees of brightness, light values) in that area. The light meter couldn't care less about colours *per se*. It is sensitive only to the degrees of brightness of the colours. So, no matter if you are shooting black and white or colour, you must develop your ability to see everything in terms of its degrees of brightness or tones if you want to become really good at exposing each particular image the way you want. This takes time, and nobody ever

becomes perfect at it. However, you can become very good.

Advanced compact digital cameras and single-lens reflex digital cameras have histograms to help you to expose properly. The histogram is a graph that shows you the tonal values the camera has recorded. This graph looks like a mountain or a mountain range, with the shadows showing on the left and the highlights showing on the right of the graph. A good exposure will not have "the mountain" cut off sharply on either side. If the histogram appears to have the left side cut off, it's telling you that you've lost some detail in the shadows. With the right side cut off, you have lost some detail in the highlights. In both cases you should re-expose, trying to have your mountain slope down gradually to the side where it was cut off. By looking at your LCD panel, and watching your histogram, you should be able to expose properly.

You may have a hand-held light meter of the incident-light variety, which you must aim at the light source. It's for measuring the light reaching the subject matter from the light source, not the light reflected from the subject matter. Because only a few very advanced amateurs and some professionals use incident-light meters these days, we will not be discussing them here.

### Determining exposure

With both digital and film cameras the really critical part of determining exposure comes after the meter has done its work. Then you're on your own, and the exciting challenges begin. Remember, the only "correct" exposure for any subject is the one you want. So you have to decide what you want and how to achieve it.

With the reflected-light meter, once you have determined the exposure that will give you middle grey, you must "open up" or *put light back into light subjects*. You must "close down" or *take light away from dark subjects*. (Read these two sentences over and over and over again until you are certain that you understand them.)

Let's be specific. Pretend that it's winter and you want to photograph a field of snow. If you measure the intensity of light reflected from the snow with your reflected-light meter, and follow that measurement, you will get middle grey snow because the meter always tries to give you a reading that produces middle grey. So, to put the white back into the snow, you'll have to "open up" (that is, give more light by using a wider lens opening, a slower shutter speed than the meter indicates, or both). How much extra light you give will depend on your judgement, experience, and taste.

Or, imagine that you are facing a dark storm raging over the ocean. The sky is utterly ominous, and the water is black. Here or there a long shaft of light penetrates the clouds, striking and illuminating a wave. Although your camera meter will give you an exposure close to middle grey, because that's what it always does, you will have to "close down" or underexpose (that is, take light away by using a smaller lens opening, a faster shutter speed, or both). To capture both the reality of the scene and the feelings it evokes, you will have to underexpose.

Most of the time you will probably want the overall brightness of your picture to replicate or approximate the brightness of the scene, situation, or objects you are photographing. In these cases you will follow what the meter indicates.

With a digital camera you can check your results right away, and either increase or decrease your expo-

sure, if necessary. However, you must be able not only to read the histogram with reasonable accuracy, but also be able to interpret what you see in your LCD. In many light conditions, this may be very difficult. Although you can sometimes (loss of highlights or shadow details cannot be recovered) make adjustments later on your computer, we recommend that you try to "get it right" in the first place, as this will save you time later, and it will develop your long-term ability to assess light conditions accurately. Never regard a digital camera as giving you a licence to be sloppy or haphazard about exposure.

With a film camera, nothing beats a little trial and error in learning what to do. In the beginning you may want to bracket your exposures. Take one picture at the setting that you think is most accurate, then another that gives a little more brightness, and another which gives a little less. This is fine—for a while. But don't let it become a habit, because it can be a terrible waste of film, and it may become a crutch, an excuse that forever prevents you from achieving precise exposure control. However, if you feel that you must bracket an exposure, try doing it in one direction only. Decide if it's a little more exposure or a little less that you may require.

If you want to learn to get exact exposures, give up bracketing altogether. For two months of continuous shooting or for twenty rolls of film, permit yourself only one exposure of every picture you make. Knowing that you have to succeed with that single exposure, you will exercise a great deal of care and common sense that you may have allowed to lie dormant. The results should be dramatic. The experience, invaluable. Discipline is a great teacher.

Some photographers keep notes about their exposures. We don't recommend this, except in exceptional circumstances. It's far better to make your assessments simply by studying your slides or negatives, because all the information about what you did, correctly or incorrectly, is literally there before your eyes. Besides, when you're photographing at the local soccer field or travelling abroad, your notes will probably be home in a drawer.

Some photographers carry a (middle) grey card with them and take a meter reading off the card instead of off the subject. But the card is one more thing to carry, and you should learn to operate without it. If you're photographing a tiny flower against a background of dark evergreens, you'll have difficulty obtaining a meter reading from the flower. Be careful. Don't include the dark background in the area you meter. Meter the area of tone you want most, and let the dark background take care of itself, which it will. A grey card would be very handy in this situation, but you can usually find something nearby that is approximately the same tone as the flower, and you can meter off that instead of a grey card or the flower itself. Try to keep your exposure methods simple. Don't start worrying when a very simple solution is almost invariably close at hand.

Don't forget that determining exposure is a subjective matter. If, for example, you are photographing in the forest, and the trees seem almost ominous in their size and darkness, you may have to ignore what your exposure meter tells you in order to record the impact which the subject matter is making on you. Remember, you are photographing the *effect* the trees have on you just as much as the trees themselves. So, you may choose to underexpose in order to darken tones overall

or to reduce some of the murkier areas to pure black. In other words, you deliberately control exposure in order to record the ominous quality. Overexposure is equally effective when your response to a subject demands desaturating colours or lightening tones throughout the picture, as in images showing misty conditions.

It may be useful to know that when you move from one f/stop to the next higher one (from f/8 to f/11, for example), you are cutting in half the amount of light that reaches the film or sensor. If you go the other way (from f/11 to f/8), you are doubling the light. You can also cut light in half by shooting at one shutter speed faster ($\frac{1}{125}$ second instead of $\frac{1}{60}$ second), or double the light by moving one speed in the opposite direction, that is by shooting more slowly ($\frac{1}{30}$ second instead of $\frac{1}{60}$ second, for example).

If you want an underlying guide to film exposure, then keep this one in mind. When using colour slide films, more often than not you should choose an exposure that will render highlights accurately. When using black-and-white film or colour negative film, more often than not you should choose an exposure that will produce good detail in the shadow areas. Overexposure of the highlights can be corrected in the darkroom when you are making black-and-white prints, if the overexposure is not too severe. However, there is noth-ing you can do to add detail to shadow areas, if the negative had none in the first place.

This is the place to mention some basic facts about exposing negative films. By altering the exposure of a negative and the time it is developed, you can produce marked changes in contrast and graininess. Negatives that are underexposed and overdeveloped will show more contrast than normal. Negatives that are over-exposed and underdeveloped will show less. Negatives that are both overexposed and overdeveloped will show more graininess.

Don't throw away your exposure failures without examining them carefully. Mistakes are inevitable. But they will be useful if you take time to study what went wrong. Sometimes mistakes suggest new avenues of exploration. For example, if you photograph with slide film and some of your images are overexposed, these can sometimes be salvaged by sandwiching them with some of your other slides. This is called "montaging," and you'll be amazed at some of the composite images you can come up with. A couple of years ago on a spring workshop, one of the participants would go through the trash cans every night collecting slides tossed away by other participants. On the final day, he gave us a slide show of montages made up of the weeks' rejects, leaving all of us speechless.

# Symbols and design

*Symbols.* The major challenge of photography is how best to describe the meeting between your subject and yourself—in other words, how to make good pictures. Nothing will be more valuable to you in meeting this challenge than an awareness of the symbolic content of your subject matter. What does it suggest to you? What does it evoke? What is it likely to suggest to others?

"To symbolize" comes from the Greek word "symballo" which, in its original sense, means "to bring together." This elementary definition is helpful for photographers, because it suggests three important ways in which a symbol "brings together."

1  A symbol is the means by which something is made intelligible or accessible to us. It brings events or truths together in a coherent pattern. It establishes unity where otherwise there would be only a chaos of forms. A symbol does for visual composition just what it does for language, social customs, and religious ceremonies.

2  A symbol is a meaningful centre that gives shape and pattern to the response of a person viewing a photograph, or to the beliefs and conduct of society.

3  The most marked characteristic of a symbol is its capacity to encompass an almost limitless variety of meanings and relationships.

One might say, then, that a symbol brings unity to something not previously unified, and in doing so opens up a level of reality that would otherwise remain hidden. This has important implications for visual design, as we shall see later.

Everybody uses symbols constantly. Real communication is impossible without them. And any language, oral or visual, is only as rich as its symbolic content.

In an age where shaping and reshaping a person's image is not just a personal activity, but also big business, we regularly and deliberately try to influence others to see what we want them to see. We use symbols to do this. A symbol in itself is neither true nor false; it is a cohesive element that gives shape and pattern, enhances,

and brings order to a particular reality. It makes recognition and understanding possible. Nevertheless, many symbols fail to communicate what is intended, and therefore cease to be symbols. The failure may be either with the person who sends or who receives the symbol, or with the symbol itself. Let me explain.

Blue denim jackets and jeans are rugged clothes for work and play, easy to launder, comfortable to wear, and inexpensive when compared with most other jackets and trousers. They are useful and practical clothes, but they have also become common and powerful symbols. Does a person pull on a pair of faded jeans because 1/ they are the most useful and most comfortable trousers to wear under the circumstances, or 2/ he believes that they connect him with a particular group of people or state of being, or 3/ a person wants others to *think* that he belongs to a particular group or has a certain kind of personality, whether he actually does or does not? It's sometimes very difficult to decide whether the clothes are a symbol or not, and if they are, what they symbolize or are intended to symbolize.

Pictorial composition raises many of the same problems. Many photographers use basic formulas of design that 1/ may be the most appropriate to a given subject matter, or 2/ may be what the photographer believes to be the most appropriate, or 3/ may be what the photographer wants others to think are the most appropriate, because any other pictorial approach will isolate him from his photographic peers. Acceptance, with blue jeans and with pictorial composition, is often the name of the game. Wear blue jeans and be accepted in the group. Use approved formulas of composition and have your photographs accepted at the camera club. There really isn't any difference.

There are, basically, two kinds of symbols: symbols of style and symbols of content. Let me give you some examples. Why do some people commonly use vulgarities in normal conversation? In their minds, these words (symbols of content) may convey an impression of the kind of person they are. The listener may or may not understand the use of these words in the same way. If he does, the speaker is doubly successful, convincing both himself and the other person that he is, in fact, the personality he is projecting. The image and the reality are identical. If, however, the listener is offended by the language, or regards the use of these words as a "mask" or a "front," the symbols fail and so does the character projection.

Symbols of style are no less important and no less common. How a person says something is just as important as what he says. It provides just as much information. A word or phrase can be spoken in different ways and communicate very different meanings.

The serious photographer must consider the potential meanings of his symbols. First, he must ask what his subject matter (content) is likely to suggest to others. Second, he must ask what his treatment of that subject matter (style) is likely to convey. Third, he must ask if his content and style are harmonious. Is there a unity of impression? A person who proposes marriage in an angry tone of voice is using disharmonious symbols. The words (content) and the tone of voice (style) just don't go together.

A photographer's subject matter must harmonize with his style in order for the photograph to convey meaning. This fact is of paramount importance to photographers and indeed to anyone working in a visual medium. Nevertheless, it is a fact that some photogra-

phers never consider, and as a result they end up employing gimmicks and producing confusion, rather than effective visual images. Any photographic technique, such as dramatic lighting, solarization, or underexposure may help the creative photographer, but only if he carefully analyzes the symbolic content of his subject and uses techniques that strengthen the content.

**Symbols and design.** Healthy concern for analysis does not take the joy out of photography. Quite the contrary! It helps make photography a deeply satisfying, creative adventure. It adds infinitely to one's satisfaction to deal in depth with the medium, not just to skim the surface.

A photographer should always be conscious of what the subject matter and his treatment of it suggest both to himself and to viewers. This is one of the most important factors in picture control and has a bearing on all other factors—lighting, exposure, depth of field, and so on—but it has fundamental importance for pictorial composition and graphic design.

All design has the potential for symbolic effect. Photographers who intend to explore the medium in a creative way must be aware of this. They must realize that tones, hues, shapes, and lines create both physical and psychological impressions. A line that moves in a strong oblique direction across the picture space physically leads the eye. But, it also moves the mind. The viewer asks, however subconsciously, why he has been led across the space, and he must be given an answer. If the line is intended to be beautiful in its own right, the viewer should be able to perceive that. If the line points to, and thus emphasizes, another element of composition, the viewer should be able to recognize that. Obscurity in art is not a virtue.

Failure by the viewer to see what is intended is not always the photographer's fault. The viewer may not have the experience necessary to recognize the photographer's intention, which is why many artistic creations appear obscure to many people. But every artist must grapple with the problem of how his personal understanding *potentially* will be recognized.

While every serious photographer makes images to please himself or herself, nobody makes every image for this reason alone. Nobody is a complete emotional hermit. One reaches into oneself in the act of making photographs, but one also reaches out. Photography, like every other creative endeavour, exists in the tension between total self-indulgence and the need for understanding.

**Design or composition.** When we talk about design or composition we are speaking, to a very large degree, about the "reaching out" of an artist toward others. This is not to say that an artist in any medium may not employ purely personal, self-directed composition, that only he or she understands. It's just that it's impossible to talk about this sort of composition, because it's totally personal. So, when we talk about design, we are talking about communicating.

More often than not, design is the vehicle that carries the content of an image. Less often, design is the content. When design is not the main subject of a picture, it should not be treated as if it were. It should be in keeping with the subject, but remain secondary to it.

This means, for example, that if you are photographing a scene of magnificent autumn colour, you will be sure that the person walking down the road is *not* wearing a scarlet coat. The figure, which is present merely to provide scale, should not compete for visual attention

with the colour of the leaves. Similarly, the use of a stark black background and strongly dramatic side lighting in the photograph of a delicate wildflower draws attention to the strong contrasts in the image, and takes attention away from the intended centre of interest. When technique overwhelms content, the message is destroyed.

"Good design lies down quietly and behaves itself" is a useful principle and a piece of plain good sense. It is more valuable to a photographer than a good deal of specific advice about composition, such as "the ideal place for a centre of interest is $\frac{1}{3}$ of the way from the top or bottom of the picture space, and $\frac{1}{3}$ of the way in from either side." The first advice is a principle; the second is a formula. In artistic matters you should consider principles thoughtfully, but you should regard formulas with a healthy amount of distrust. A principle can guide you. A formula may enslave you.

The most important elements of two-dimensional visual design are: *lines* (their direction, length, and thickness), *shapes* (their size and placement), *textures* (the illusion of surface roughness and/or the weave or fabric-like structure of surface materials), and *perspective* (the illusion of depth). These elements of composition are made visible by contrasts of tone and hue, which can be slightly or radically altered by changing light.

Composing a photograph is the act of organizing these elements in ways that will show your subject matter, or your feelings about it, most authentically. Good design brings order and meaning to a visual construction. It conditions the viewer to recognize that order, which means to receive your message. If your composition does not bring clarity, order, and meaning to your subject matter, it is a poor composition.

Every photographer should remember that a viewer will interpret the elements in a picture in the simplest possible way. This is Gestalt psychology's basic law of visual perception.

No matter how intricate or complex a photographic composition may be, the maker has the responsibility of organizing the details so the function of each one is integrated into the whole. The form of a photograph is its wholeness—the totality of its elements, tangible and intangible. Any discrepancy between the form and the meaning of a picture interferes with its simplicity. This is why you are more likely to make good compositions when you carefully think through the reasons for making pictures.

It's also important to remember that vision responds according to the basic laws of nature. The eye will perceive natural order, and will tend to reject unnatural arrangement or correct it automatically.

Although this is a basic condition of human visual response, it doesn't mean that everybody sees things the same way. Objective and subjective order are not always identical. If they were, artistic style would be perfectly uniform and perfectly static. If you choose to stand on a rock and your friend chooses to stand in a grassy meadow in order to photograph the same landscape, each of you will see it differently and produce different perspectives of the scene, but both of you must still organize the visual elements in ways that are intelligible. Both of you must seek a basic pattern that will bring order to the complexity of lines, shapes, colours, and tones.

However, the organization of visual images requires more than attention to simplicity and basic order, because the search for simplicity leads to perfect har-

mony, to an absence of change, to immobility. In pictures, as in life, we need tension. People crave challenge, adventure, and movement.

Life itself is an interplay of tension-heightening and tension-reducing forces. The dynamic and the static, pulling against each other, work together. Since photography has to do with life, can we possibly expect that the forces that are so basic to life will be unimportant to visual perception and to composition?

How do you put dynamics into a picture? Much of it will already be there in the form of lines and shapes that are not symmetrical and which create a sense of imbalance, force, or tension. The real question is how to make this tension work—how to organize and direct it.

The theory is fairly simple, and Rudolf Arnheim expressed it well: "The dynamics of a composition will be successful only when the 'movement' of each detail fits logically in the movement of the whole. The work of art is organized around a dominant dynamic theme, from which movement radiates throughout the entire area. From the main arteries the movement flows into the capillaries of the smallest detail. The theme struck up at the higher level must be carried through at the lower level, and elements at the same level must go together."

In practical terms, if you have an empty, static area in your picture, you may be able to alter lighting to cast oblique shadows across it. These lines will be especially useful if they lead to an important shape. Or, you may add a small, dark figure to a very light, misty scene. The differences in tone and size between the figure and the rest of the picture break up the static quality; they add contrast. Contrast of any sort produces tension and makes a composition dynamic. You must be careful, however, not to add so much contrast that the mood of the picture is destroyed. In making pictorial compositions, try to assess every situation individually. Sometimes the use of different colours, and the amount and placement of them, will produce the tension you need. At other times you will depend on lines, shapes, or colours. Do your best to avoid repeating the same solution time after time.

Only a small amount of good sense about design can be taught. The rest grows in a person. However, here are some basic problems and solutions to consider. To strengthen a shape you may 1/ increase its size by moving closer to it, 2/ make it lighter or darker in tone than surrounding shapes, or 3/ place it at the end of a leading line or convergence of lines.

To gain a greater sense of space in a composition, you may 1/ increase the size of empty areas such as sky, 2/ reduce the size of your main subject, or 3/ introduce lines that appear to lead away from the foreground into the background.

To avoid confusion in a visual image, you may 1/ reduce the number of elements in the picture space, especially the number of different elements; 2/ emphasize a single object while de-emphasizing other objects, so the viewer's eye no longer moves rapidly from one visual element to another; or 3/ deliberately include lines or forms that repeat the direction, shape, hue, or tone of the main subject, but which in themselves are less noticeable.

However, it is not sufficient merely to know how to strengthen shape, gain a greater sense of space, or avoid confusion; you must determine why you want to do these things. You should have reasons for each decision you make about composition, if you want the design of your image to convey your intended message.

You will gain experience in design, not only by making and viewing pictures, but also by studying all the visual media. When you're at the theatre, notice the arrangement of the set and the way the director has blocked the action. If you're a fan of modern dance or ballet, watch the movement and flow of the dance, and note its relevance to photographic composition. As you amble through a gallery, study not only the paintings and sculptures on display, but also how the director has arranged them in the available space and in relation to one another. In short, use your eyes all the time. Photography does not begin when you pick up your camera, and learning about design should not end when you put it down. The challenges and the opportunities to learn are endless. Take advantage of them as often as you can.

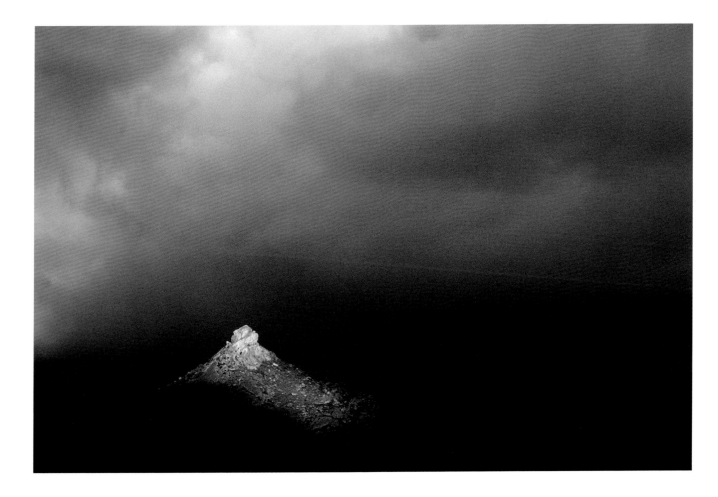

Late one afternoon in Namaqualand, South Africa, when heavy clouds rolled in and hung above the mountains, a shaft of light occasionally punctuated the gloom, dramatically highlighting a particular feature of the landscape. I chose this spot and composition, and underexposed from the meter reading by a full shutter speed to retain darkness. Then I waited and hoped, as the desired ending was definitely not guaranteed. (*FP*)

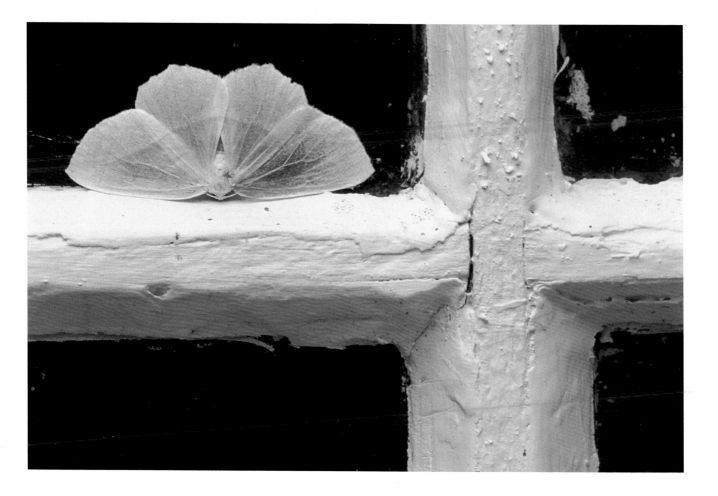

Photographers talk about "creating" images, but perhaps it is more accurate to say that God creates, and that some human beings discover. Discovery is not accidental. We discover only when we make ourselves ready to receive. Some photographers seek discovery by mastering the machinery of the craft: cameras, lenses, lighting, exposure, and design are their primary concerns. But I think photography begins somewhere else— with moths on windowpanes, or kids, or gothic cathedrals, or falling in love, or growing old. It begins with things that matter to you. (FP)

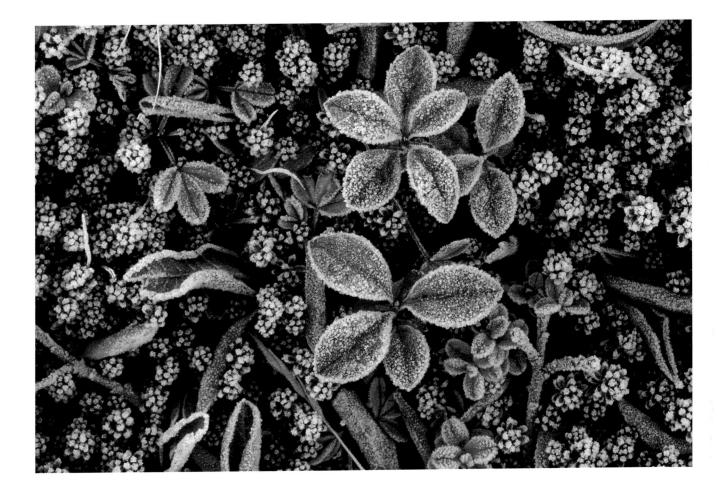

A good friend and I spent a beautiful November morning photographing on the coast of Nova Scotia. The frost that morning made everything look magical. The colours of the vegetation that grows on the escarpment is toned down because of the frost cover. The red berries stand out because the frost has not reached them. (AG)

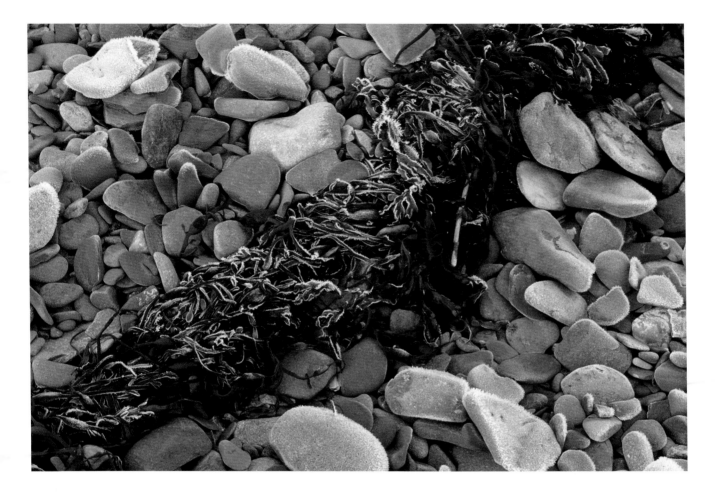

Photographed on a self-assignment in the month of November, where I had to photograph at least one roll of film for thirty days, this image makes good use of subtle hues. The composition is simple, with just two shapes and a line. Shooting on a tripod and using a cable release, I made sure to have focus and sharpness throughout the scene. (With textured images, it's often best to have everything in focus.) Although I didn't record the exposure, I was using slide film, so I probably bracketed, shooting on meter and overexposing by half a stop. (AG)

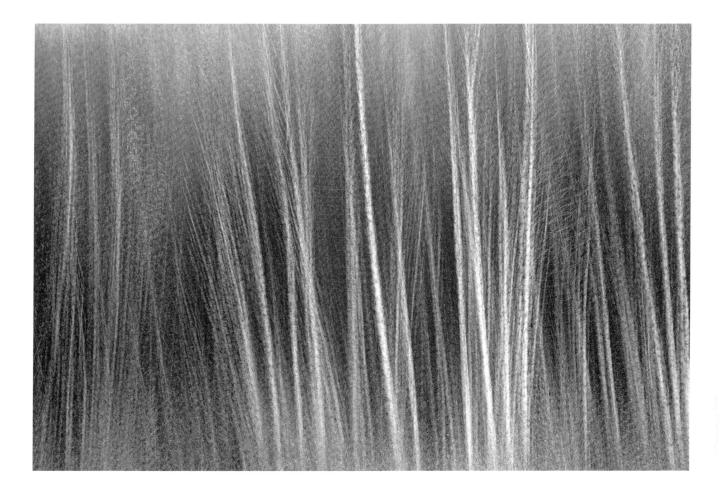

Driving along a back road on a frosty autumn morning, I was struck by the beautiful tapestry formed by the branches of birch trees, and I made some documentary photographs. However, as I often feel an urge to go beyond literal reality, I decided to make eight or nine exposures on top of one another (multiple exposures), while panning up the vertical trunks. This combination of the two techniques enhanced the natural weave by blending the tones and soft colours. If your camera has a multiple exposure feature, adventures await you. (*FP*)

For several days I walked by these weeds growing on the top of a low wall, and I knew they would die before they bloomed unless I supplied water. You can tell from the picture what I did. When you're composing, it's always helpful to "peel the labels" off the subject matter and see the material as pure design. This composition could not be simpler—a line dividing the picture space into two rectangles. I can make one larger or smaller in relation to the other by tilting my camera up or down. To keep the light tone overall, I overexposed by one shutter speed. (*FP*)

Aerial photographs fascinate me, so when I looked out the
window of my house, this view of the bistro chairs and table
set on the deck caught my eye. I got my camera and tripod,
and took this shot from that upstairs window. (AG)

The two most important aspects of design in this photograph are the highlights on the curving backs and seats of the church pews, and the colours reflected in the seats. The curving lines give the picture basic order and pattern. The colours lift the picture out of the purely documentary class, aesthetically and symbolically. It's very easy to miss pictures like this one, because it's difficult to be constantly aware of details. Learning to see what is in front of our eyes, particularly in familiar places, demands constant concentration and practice. (*FP*)

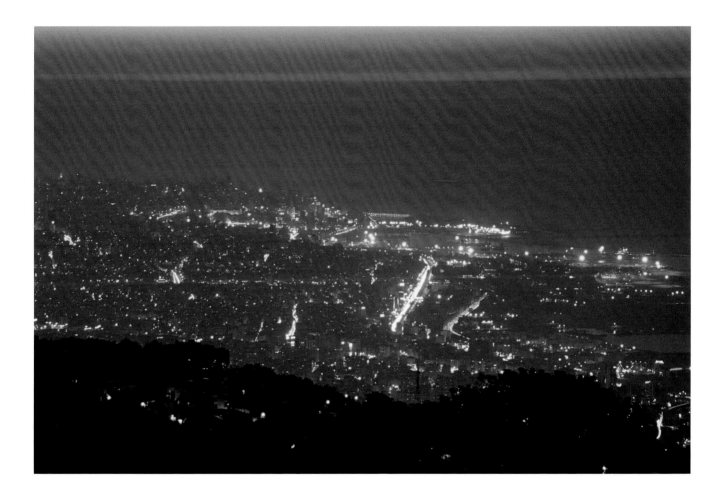

You only have a very few minutes to capture the lights of a city, like Beirut, before a sunset fades, so it's important to determine earlier in the day just where you want to be for shooting the scene and to make sample compositions. Once conditions are getting close to what you want, meter the scene and quickly decide if you want to follow the meter, or give a little more or less light. City lights will not affect your meter reading unless you are very close to them, so ignore them for your exposure calculations. (*FP*)

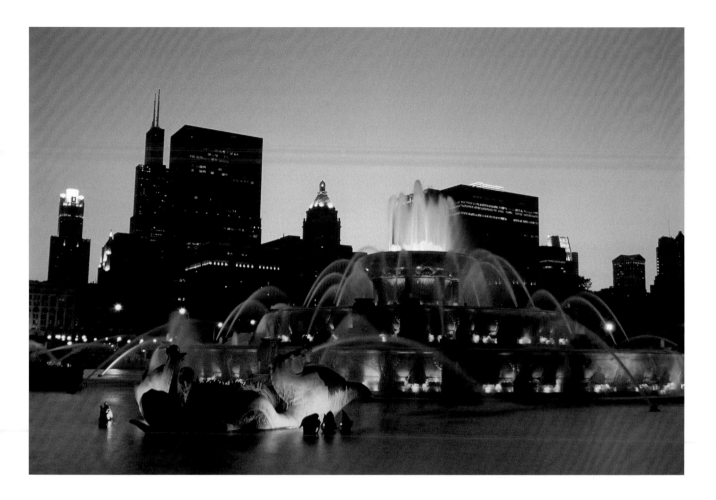

When I worked on Pierre Berton's book *The Great Lakes*, I was asked to photograph the city of Chicago. I spent a couple of days shooting the city's ethnic neighbourhoods, skyline, beaches, and waterfront. One evening, as I was walking to where my car was parked, I saw this fountain lit up against the city and the sky. In an instant, my camera was secured to the tripod, and I composed the image and took a few time exposures of the urban scene. For most of the shots, I used a camera meter to determine exposure, and bracketed by adding half a stop to a full stop to each photograph. Once the sky had lost its colour, I packed up my gear and called it a night. (AG)

As I was driving home from a shoot, I noticed that the low setting sun was casting the cathedral steeple's shadow onto the fog that was rolling into Saint John. I quickly found a parking spot, grabbed my gear, and ran to an open area with a clear view, free of power lines. I shot a couple of frames of the mystical scene. Within minutes, the fog enveloped the light and the city. (AG)

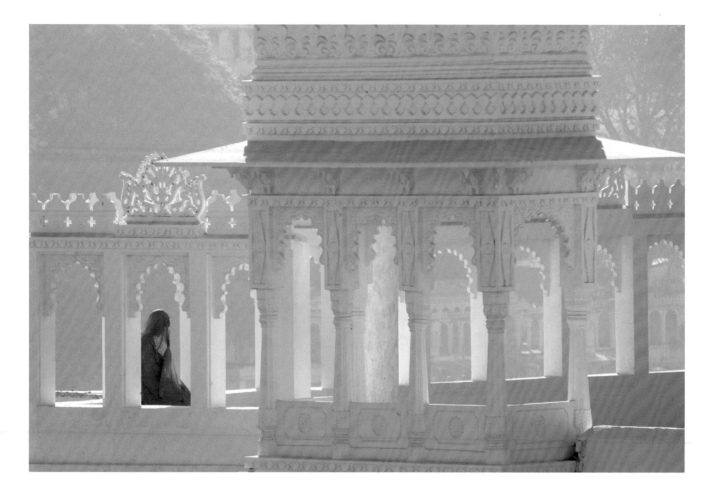

The mauve temple and figure were photographed in Udaipur, India. The scene was nearly flawless, aside from a large wooden pole rising across the temple. Fortunately, using Photoshop and the Clone Tool, I was able to remove the distracting pole in a matter of minutes. (AG)

# Point of focus and depth of field

Still photography is a two-dimensional medium, but focus and depth of field have to do almost exclusively with the apparent third dimension—depth. A sense of depth is critical in the design of most photographs. Therefore choosing a point of focus and deciding upon the depth of field you want are among the most fundamental aspects of composing a photograph. However, they deserve consideration apart from other elements of composition, because depth of field is related to exposure and is not purely a matter of design.

To put it simply, the point of focus is that subject in your picture on which you focus your lens. The depth of field is the span of distance in front of and behind the point of focus that appears fully sharp. Regardless of the lens you are using and no matter what you are focused on, depth of field is greatest at minimum apertures (f/22, f/16) and shallowest at maximum apertures (f/1.4, f/2.8).

With every lens and every lens opening you select, the depth of field (except for extreme close-ups) extends forward ⅓ of its distance from the point of focus, and backward ⅔ of its distance. To put it another way, there's always twice as much depth of field behind the point of focus as in front of it, which is a very important point to remember, especially if your camera does not have depth-of-field preview capability.

## Choosing depth of field

If you are using a 50mm lens, and not making any close-ups, you could simply set the point of focus at about 4½ metres and not bother to change it much. If you use a reasonably small aperture (f/22, f/16, or f/11), you can be certain that everything behind the focal point will appear sharp, and that the apparent sharpness will extend forward from the point of focus to about 2, 2½, or 3 metres from the lens. This should cover everything you want in focus. Maximum depth of field was used in the photographs on pages 26, 136, and 146.

If you always wanted as much depth of field as you could get, there would be no large lens openings, no problems, and no chapter on the subject in this book. But, that's not the case. Sometimes the subject matter

virtually dictates that you reduce or limit depth of field; and at other times you will decide on restricted depth of field for purely personal reasons.

The need for maximum depth of field is usually self-evident. You view the total picture area, and feel that having any part of it out of focus will be distracting. On other occasions you will view the picture area and decide that having anything besides the main subject in sharp focus will be distracting, so you will choose minimum depth of field, as I (Freeman) did in the photographs on pages 15 and 153.

Because these decisions are often easy ones to make, it does not mean that they are unimportant. Photographs, like medicines, do not necessarily have to be difficult to take in order to be effective. If you decide quickly on the depth of field you want, don't automatically assume that you're visually naive or that you should fuss about awhile longer. It may, instead, be an indication of your growing expertise in assessing visual impact and pictorial effect.

Nevertheless, the real test comes with the intermediate f/stops, that is, with partially restricted depth of field. Deciding between f/11 and f/8 is rather like deciding between one bay leaf or two for the pot of soup you're making. The finest flavours result from the most subtle adjustments to the recipe. Well, how do you decide?

The matter should be considered both negatively and positively. Let's examine the negative approach first. Certain compositions fail because some elements in the picture are visually bothersome. Perhaps showing through the trees is a spot of light sky that pulls your eye away from the clump of ferns you're photographing, simply because it's so much lighter in tone than the ferns. You cannot alter the position of your camera to eliminate the bright spot without ruining the rest of your composition, so you reduce the impact of that bright spot by pressing your depth-of-field preview button, and then moving to successively wider lens openings until the spot is diffused enough (out of focus) to stop being a distraction. Meanwhile, because the ferns are the objects on which you focused in the first place, they will remain sharp and clear. This is the negative approach to deciding on depth of field—a way to improve composition by eliminating distractions, or by reducing them at least. It's an important basic method and frequently must be used along with the positive approach.

The positive approach to determining depth of field can be stated simply. Assuming there are no major distractions in the picture space, you select the depth of field that produces the suitable degree of emphasis on your main subject or on the total impact of the image. Such a decision demands personal judgements. A teacher of photography can easily spot a bad decision; he should also be able to recognize the near misses and help to correct them. But, in the end, the student cannot rely on somebody else's feelings and advice. He or she must make the final choice. As you look at the image you are composing, you must remember to value your own instincts. You must be willing not only to think, but also to say, "This depth of field *feels* right to me." Then you must press the shutter release, and later examine the results.

In learning about depth of field, look for guidance from your camera club, your photographer friends, magazine articles, and from viewing pictures. But don't look for formulas. Like so much else in photography, selecting depth of field becomes part of your style, your

personal statement of who you are and how you respond. Every time you choose a formula over a personal decision, you are denying a part of yourself.

The negative and positive approaches frequently coincide. Often your potential image confronts you with two problems—how to reduce the effect of distracting elements and how to select the depth of field that is most compelling. Sometimes you cannot solve both problems simultaneously, and eventually have to admit defeat and select a new image. While you may be disappointed about this, don't be downhearted.

The chances are quite good that you can find a solution in most cases, or at least achieve a compromise that you can live with. The whole business of trying is, in itself, an education in composition. Try shifting the point of focus, and viewing the composition at the various f/stops. Shift again, view again. And again. Keep at it until you've exhausted the possibilities or discovered the best combination.

Don't forget that you can pause at points between the f/stops on your lens—and you should whenever your selection of depth of field or exposure calls for minute adjustment. There will be many times when f/8 is almost right and f/11 is almost right, but halfway between the two is exactly right. Don't think of your lens as a piece of equipment with six or seven adjustable settings. Think of it as a continuum, as an infinitely variable apparatus that has only two restrictions, one at each end of the f/stop scale. And remember, all of this is much easier to think about and to do when you have your camera on a tripod.

At the beginning of this section, we said that depth of field is not just a matter of design, but is related to exposure, and that depth of field also influences the sense of a third dimension in an image. Let's look at these two statements in turn.

## Exposure and depth of field

When you are composing most images, choosing your f/stop (that is, choosing your depth of field) is far more important than choosing your shutter speed. Only after you have settled on the depth of field and an f/stop should you read your meter and select the shutter speed that will give you a satisfactory exposure at that f/stop.

There are some important exceptions to this principle. For example, you may have a strong preference for photographing flowing water at very slow shutter speeds—the longer the better. In many lighting situations this forces you to use a small aperture, usually f/22 or f/32. Therefore, you have to live with maximum depth of field, and simply make certain that having every picture element in clear focus doesn't mean including any distracting features.

## The perception of depth

What is the influence of depth of field on a sense of depth in your images? What about perspective, the illusion of depth on a flat surface? While other factors of composition (such as lines and shapes) affect all three dimensions, the primary impact of any given depth of field is on the depth perception only. This is why we have separated it from other elements of design.

Do not assume that the picture with the greatest depth of field will automatically convey the greatest impression of depth to the viewer. A line that begins in the foreground and leads off into the distance may appear longer to some viewers if it becomes increasingly out of focus as it moves toward the

background than if it remains sharp. This perception may be a learned one, or it may be a purely individual response. Whichever it is, the photographer should extract a principle from it—that many visual constructions say more by what they suggest than by what they show.

So, once again, choosing depth of field enters the realm of subjectivity. All human beings do not have the same perception of depth. Some of the images that we enjoy most are ones that lack a precise definition of depth, which allows us to shift our visual and emotional viewpoint while looking at them. The uncertainty of visual perception will frustrate you only if you are looking for formulas or rules in order to operate. Most of the time it should excite and challenge you.

# MAKING PICTURES

# The importance of using your camera

The most important thing you can do with your camera and lenses is to use them. Reading books and taking photographic courses can be very useful, but they can't begin to approach the value and pleasure of using your equipment regularly. A typist soon loses his speed if he doesn't use his keyboard frequently. A photographer loses her ability to make precise exposures if she packs her gear away once the leaves have fallen off the trees. And worse still, if you do this you stop growing as a photographer. Your knowledge of the craft suffers. Your ability to visualize keenly begins to stagnate.

A few years ago a friend and I (Freeman) built a house, working away through autumn into winter. Most mornings when I climbed up on the roof, the air was frigid. Frost lay on black shingles like peppermint icing on a chocolate cake. On the mornings when there wasn't any frost, there was often snow. I brushed it off the dormers and the staging so I could get to work, pausing occasionally to view the white-wreathed cedars from a favourable vantage point.

The photographer's eye was always at work, though sometimes with disastrous results. I acquired a multitude of blood blisters, every one agonizing testimony to the fact that I was looking at the scenery when I should have been watching my hammer. But, I learned! I learned that I could be a carpenter and a photographer at the same time. I discovered that there is time to make pictures every day, no matter how busy I am.

Most amateurs don't take a camera to work with them, and for the first few days of being a carpenter, neither did I. Very foolish of me, because most of those missed opportunities won't come again. I'm not sure what made me wake up, maybe a particularly lovely sunrise through the snowy spruce or the pattern of afternoon light on the rows of roof beams. But I do know that, before long, I picked up a camera every morning along with my saws, hammer, and nails.

Having a camera with me, even when the whole day was devoted to building, was a very healthy thing. It's known as being prepared. Nobody works for eight or

ten hours without stopping, not even me. There was lunch at least, and usually a short break for a thermos of hot coffee. Wandering around with coffee in one hand and a camera in the other was a lot more relaxing than just sitting on my fanny. It was a total diversion, a complete change. Added to that was the fact that I did get quite a few good pictures during these short respites. I would go back to work ten or fifteen minutes later feeling that I was not a captive to my job, that it hadn't utterly consumed my day or my spirit.

What's possible for a carpenter is just as possible for the photographer who's a truck driver, a computer programmer, or a meteorologist. Having a job with regular hours doesn't mean that you can never make pictures during those hours. To begin with, there's lunch hour. Most people don't spend much time eating, but use the break for shopping, or reading, or just chatting. It's a perfect time to make pictures—and the change can do wonders for your spirit. Leave your tripod behind at first; take your camera and only one lens. Pick just one subject for the half hour you have available—reflections in windows, shadows, a school-crossing guard helping small children—but choose a subject that appeals to you. The next day try the same subject again, but with another lens. Stay with your subject until you find yourself wanting to turn to other things.

If it's raining heavily, set up your tripod in the office. Try still-life arrangements of books, pencils, and office equipment. Work on the patterns of water on the windowpanes. Shoot down at the street to catch people hurrying by in their brightly-coloured raincoats and umbrellas. If your fellow workers think you've gone slightly crazy, don't let it bother you. In a couple of days, they'll ignore you. But after a month or so, invite a few of them to your home for an evening and put on a show of the images you've made during lunch hours. Or just show them some on your computer's monitor. From that point on, they'll be coming to you with suggestions, and you'll also find it easy to make photographs of them.

By shooting a few minutes every day, you will develop your photographic skills, increase your ability to see good images, and soon have an extensive collection of slides or negatives. In fact, once you start photographing during lunch hours and coffee breaks, you'll probably make more pictures than you ever will if you wait until you get home, because all the good intentions you had during the day will have dissipated by the time you plop yourself down in an easy chair. If you don't carry a camera to work, you can go for months without ever making a picture. And to experience the joy of being a photographer you have to make pictures.

Selective focus is an important technique directly related to depth of field. Strictly speaking, every photographer uses selective focus every time he or she makes a picture. Choose a point or plane in the picture area on which to focus, and then select either 1/ a small lens opening, such as f/16 or f/22, which will keep all other picture detail pretty well in focus, or 2/ a larger lens opening, such as f/3.5 or f/5.6, which will throw some of the picture out of focus. However, in popular usage, selective focus has come to mean only the latter—the use of a wide aperture to achieve a very shallow depth of field, a definition we will use here. Several photographs in this book have been made with this technique, for example, on pages 71 and 155.

Some photographers use selective focus to achieve particular effects, such as softening harsh lines, blending background colours, or making the centre of interest stand out distinctly from other elements in the composition.

Others use it to create certain moods or patterns. The photographer who uses it well usually has considered its purpose carefully. No technique, in itself, has any intrinsic value. The value comes in its being applied successfully, to accomplish the photographer's aims.

But let's discuss a specific example of selective focus.

Imagine a vast field of daisies stretching away from your feet to a deep green forest. In the field, about halfway between you and the woods, a group of children is playing. Basically, you have three areas or planes in this situation. 1/ a *foreground* of daisies; 2/ a *middle ground* with the children and the flowers immediately around them; and 3/ a *background* of trees.

You may want to use a lens opening of f/22 and put every part of the scene in sharp focus. On the other hand, you may feel like creating a dreamlike atmosphere, a special feeling of summer, or a nostalgic look at a summer of your memory. If so, selective focus may be your best answer, and here are three different ways to try it.

1  You may wish to focus on the foreground, and use a wide lens opening, such as f/2.8. This will keep the nearest daisies sharp, but will soften the detail of the

children and the daisies around them, and the background as well. The children will appear, not as recognizable images, but as vague figures of children. The forest beyond will become a soft green backdrop. Such an image may have far more allure than a photograph that is in focus from front to back.

2   You could crouch down and shoot through the daisies, but switch your focus to the middle ground, where the children are playing. With the same wide lens opening, the foreground flowers will now become blurs of white and gold dancing across the picture. Through them the children may be seen sharp and clear, but almost as if they were in a dream. Behind, the forest will still be a soft green backdrop.

3   You might focus only on the forest background, although the effect in this case may not be very strong. However, in other cases, throwing both foreground and middle ground out of focus, while keeping the background sharp, is very effective, indeed. In Dawson City, once, I (Freeman) wanted to photograph the outside wall of a log cabin. However, as I looked through the viewfinder, I found the lines of the old logs too strong and straight for my liking. I wanted to soften them, to induce a visual element that would make the logs seem a memory, or a symbol of memory. So, I backed away through a tiny field of fireweed. Then, taking a low camera position, I aimed through the fireweed, but focused on the logs of the cabin. The out-of-focus pink circles of fireweed in the foreground softened the overall pattern sufficiently to eliminate the harshness in my original composition, and introduced a new and suggestive element, an intangible sort of colour

and shape. I was presenting a cabin somewhat obscured—clouded, if you like—by the passage of time.

Selective focus may be achieved with any lens, but for most photographers it comes more easily with a lens longer than 50mm, because with longer lenses the depth of field appears to be so much shallower than it does with a short lens at the same opening. Also, close-up equipment is very useful for creating selective focus, because the closer the subject you are focused on, the less depth of field you have.

One of our favourite times for working with this technique is at sunset, especially on a night when the sun is a huge red orb descending through a misty sky. Often we race for our 100mm macro lenses, or for some other close-up equipment, and then plop ourselves down in the middle of a field of long grass. If we quickly extend the lenses to minimum focusing distance, about 15 centimetres, and set them at their widest aperture, the combination gives us an extremely narrow depth of field.

When we point our cameras at the setting sun, something fantastic happens! Because the sun is completely out of focus, it is tremendously enlarged and fills much of the picture space. A circle becomes a bigger circle when it's thrown out of focus, and the more it's out of focus the bigger it becomes.

But that's not all. As we crawl through the grass, individual blades of grass, flowers, and seed heads brush against the lens, passing from out of focus to in focus then out again. When a grass or combination of grasses forms a delicate composition against the backdrop of the huge red sun, we pause and carefully inch forward

or backward until we're satisfied we have the best arrangement possible. Then we press the shutter release.

To get this effect, remember that 1/ you must use the widest lens opening (nothing else), because otherwise the out-of-focus sun will appear hexagonal, not round, and it will not fill as much of the picture area; 2/ you must leave the lens at minimum focusing distance, because this also enlarges the sun, and move slightly forward or backward to get the point of focus precisely where you want it.

Since the lens is at maximum aperture and admitting a great deal of light, your meter will indicate a very fast shutter speed, probably starting at $\frac{1}{1000}$ second when the sun is still well above the horizon and moving down to $\frac{1}{60}$ second as the sun sets. The choice of shutter speed will depend on the intensity of the sun at any time and on the flowers or grasses in front of your lens, which are preventing some of the sunlight from entering the lens.

If you own a single-lens reflex camera, you'll find experimenting with selective focus and shallow depth of field very easy, since you'll be able to see in the viewfinder precisely what is in focus and what is not. If your camera has depth-of-field previewing capability, you can vary lens openings and easily choose the effect of greater or lesser depth of field. All of this is possible with many digital cameras, but not all.

Real competence with selective focus takes practice. It's easy, but it's difficult too. You may be pleased with the results of your attempts, but the more practice you get the more likely you will be able to achieve precise control in many kinds of situations. If you are keen to grasp the visual opportunities offered by this technique, stay with it. Challenge any preconceptions you have about focusing and depth of field.

# Showing motion in still pictures

There are times when every photographer would like to convey the impression of motion or movement in a still photograph. Times like this can be frustrating, if you're not familiar with some of the techniques available for conveying movement and activity. However, several possibilities are available, so let's explore them and try them. The more ways you can show movement, the more interesting your picture sequences are likely to be.

## Oblique lines

Oblique lines are dynamic lines. Unlike horizontal lines (which suggest rest and peacefulness) or vertical lines (which imply dignity, formality, and stiffness), oblique lines move the viewer's eye quickly across the picture space. They suggest that something is happening, as in the photographs on pages 68, 126, and 127.

When you're photographing a horse race or a child running, watch for those moments when bodies are on a tilt, leaning forward or into a curve. Capture the imbalance. This won't make the child or the horse look as if it were about to fall over, but rather will create a strong sense of activity in the viewer's mind, and he'll have no trouble understanding and feeling what's going on.

## Peak action

In many sports there comes a moment when the competitor reaches the zenith of his or her effort and seems to hang briefly in the air—high jumping and pole vaulting are good examples. The trick is to press the shutter release a split second before the peak of action. If you wait for the pole-vaulter to reach the highest point before releasing the shutter, you'll find you've missed the critical moment. Peak action photographs are usually very successful, because viewers instinctively imagine everything you can't show—the powerful lunge before the leap and the "thud" to the ground which follows it.

## Slow shutter speeds and time exposures

Slow shutter speeds and time exposures (any exposure longer than one second) cause the blurring or streaking

of any objects in your picture that are travelling faster than the shutter itself. The slower the speed (i.e., the longer the exposure), the greater the blur, and the more pronounced the sense of movement. If two objects in the picture are moving at the same speed, the one closer to the camera will appear to be more blurred.

A slow shutter speed, let's say $\frac{1}{30}$ or $\frac{1}{15}$ second, captures a snowstorm well. It's slow enough to make every flake look like a short white streak, but it's fast enough to stop the blizzard from looking like a downpour of rain. Another technique for a snowstorm, especially effective when combined with a slow shutter speed, is to fire a flash gun during the exposure. This illuminates flakes close to the lens brilliantly and arrests them in mid-air. You get a very snowy picture—a real eye-stopper! And it's easy because you don't have to bother calculating exposure for the flash. Just stick with the shutter speed and lens opening you've already chosen for the scene.

A slow shutter speed will also give a sense of softness to falling or flowing water. Apparently, the eye sees motion at about $\frac{1}{15}$ second, so if you photograph a waterfall faster than that it may appear frozen, particularly if the water is falling very gently. (The faster the rush of water, the faster the shutter speed required to freeze it.) When you use a slower shutter speed, you'll increase the blur of water and induce a misty quality.

The swirl of water and foam created by waves breaking on a beach are often recorded far more accurately at a slow shutter speed, say $\frac{1}{4}$ second, than at speeds of $\frac{1}{60}$, $\frac{1}{125}$, or $\frac{1}{250}$ second. However, a long exposure, perhaps thirty seconds at twilight, will transform a raging sea into a completely calm body of water. During such a long exposure many waves will traverse the picture space, but because of the low light they will not be recorded as waves at any point. This is using a time exposure (any exposure longer than one second) to stop or virtually eliminate movement, and the results can be soft and lovely.

A time exposure can create the impression of movement as well. If you are shooting during the evening and aim your lens at a street or expressway, it makes sense to try a long exposure in order to record the headlights and tail lights of cars moving across the picture space (see photo on page 97). The speed of the vehicles and their distance from the lens are important; note how long it takes two or three of them to move through your composition, then expose for at least that duration. The longer you expose, the more likely you are to record more moving lights, so you may want to use a small lens opening (f/16 or f/22) to prevent overexposing the scene. If there are a few moments when no cars are passing, simply put your hand in front of the lens. If it's dark, your hand will not record, and you will prevent overexposure of areas in the picture that are illuminated by streetlights.

The time exposure of stars (see photo on page 154), which was recorded as star trails, was approximately three to four hours long. The wider the lens you use when shooting star trails, the longer your exposure will need to be, as the stars have to rotate through a greater distance.

You can also swing your camera on still subjects like trees and flowers, which will add motion to these images. Every object in a situation where nothing is moving will be very blurred *when you move or swing your camera while exposing with a slow shutter speed*, as in the image on page 68. It makes good sense to use a digital

camera for this exercise because you can view the results instantly and determine if you're moving the camera too fast, too slow, or just about right. However, film users should not be deterred at all.

## Panning

Panning is another simple technique for giving the effect of motion in still photographs. It keeps the main subject relatively sharp while blurring the background, thus giving the impression that the subject is passing rapidly through the picture area. The photograph on page 17 shows the effect you get by panning. It is so simple, and usually so successful, that photographers trying it for the first time are often amazed at the results. Here's how you do it.

First, you get ready. 1/ Any camera or lens will do, but a 100mm lens or longer is best, unless you're very close to the moving object. 2/ Choose a slow or medium-speed (ISO 50 or 100), unless the light level is low or you are using a neutral density filter, because panning is usually done at $\frac{1}{8}$, $\frac{1}{15}$, or $\frac{1}{30}$ second. If you're using ISO 200 or 400, you'll be overexposing at $\frac{1}{15}$ or $\frac{1}{30}$ second in bright light, since most lenses don't stop down beyond f/22 or f/32. 3/ Pre-focus on the area where the subject will be when you actually make the picture; then don't worry about adjusting the focus again.

Now you are ready to make the picture. 1/ Pick up the moving object in your viewfinder and follow it as it approaches. 2/ As it passes through the area on which you pre-focused, press the shutter release, but don't stop following the moving object. Keep swinging, just as a baseball player follows through with his bat once he has hit the ball. If you don't follow through, you'll invariably stop swinging before you actually press the shutter release, and get no effect of motion at all. And that's all there is to it!

## Zooming

If you have a zoom lens, you'll find it comes in handy for implying movement where none is taking place. In zooming, all sorts of oblique lines of colour and tone emanate from the centre of the picture and travel toward the edges (or vice versa). For example, focus on a maple tree in full autumn colour, and zoom your lens (extend or reduce the focal length) during an exposure of $\frac{1}{15}$ to 1 second. The result is an explosion of colour, as in the photograph on page 126.

Here's how you do it. 1/ Set your camera and lens on a tripod, if possible, as this will make the operation easier. 2/ Choose a slow or medium ISO (50 or 100) unless the light level is quite low or you are using a neutral density filter, because you should zoom at shutter speeds of $\frac{1}{15}$ second or longer. It's difficult manually to complete the zooming any faster than that. 3/ Set your lens at the smallest aperture (f/16 or f/22) in order to reduce the light reaching the film, which will help you to make a longer exposure. 4/ As a test, compose your picture twice—once at the maximum range of your lens and once at the minimum. If your lens is an 80–200mm zoom, compose your image at 80mm and again at 200mm. The composition at 80mm will cover a greater subject area, so at this lens position be certain there is nothing in the picture that is distracting or undesirable. 5/ With your lens set at either 80mm or 200mm, press the shutter release. As you press the release, or a fraction of a second before, use your other hand to extend the lens very quickly from 80mm to

200mm, or to retract it from 200mm to 80mm during the exposure. This is called zooming.

You won't be able to pre-visualize the final effect, but the more zoomed pictures you make, the more accurate you will become at predicting the kind of results you'll achieve; you will learn when zooming is likely to work well.

## Rotating the lens

Many long lenses come with a collar attached. The collar allows you to screw the head of your tripod into the lens, rather than into the camera. This is important, because long lenses are often heavy and will cause a tripod to upset if they are not attached to it near their centre of gravity. The collar also has a screw in it which, when loosened, allows you to rotate your lens and camera from the horizontal to the vertical position without touching anything else.

You can use the lens collar in a way for which it was not intended—and the visual effects can be very striking. You can rotate your camera and lens during an exposure—in much the same fashion as zooming. But, instead of getting oblique lines emanating from the centre of the picture, you'll have concentric circles of colour and tone revolving around it.

Here are the steps to follow. 1/ Affix your camera and lens to a tripod by screwing the head of the tripod into the collar of the lens. 2/ Select a low or medium ISO (50 or 100) unless the light is weak, because you will need to rotate the camera and lens at a slow shutter speed in order to complete the rotation during the exposure. 3/ Set your lens at the smallest aperture (f/16 or f/22) in order to reduce the amount of light

reaching the film, which will help you to make a longer exposure. 4/ Compose your picture twice. First, try the camera in a vertical position (or the horizontal position, it doesn't matter). Then, release the screw in the lens collar that keeps the lens and camera from moving, and rotate the camera to the other position. Check the new composition carefully. Are there any distracting elements in either composition? If not, leave the camera in either the vertical or horizontal position. 5/ Do not tighten the collar screw. Leave the camera and lens free for rotation. 6/ Press the shutter release, and, as you press, use your other hand to rotate the camera and lens quickly during the exposure.

As with zooming, you won't be able to pre-visualize the final effect exactly, but practice will improve your ability to predict the result, and you will be able to achieve a good deal of control.

This technique may be even more effective if you make a double exposure. Make the first shot normally, but use only half the calculated exposure. (If your meter indicates 1 second at f/22, expose at ½ second at f/22.) Make the second shot at the same exposure as the first, but this time rotate the camera and lens during the exposure. The combination of reality and unreality creates an aura of mystery. You can even try zooming and rotating at the same time, or making a double exposure—one zoomed and one rotated. It takes manual dexterity and concentration, but wow!

## Sequential shooting

Since images are usually shown one after another, you can convey activity through sequential shooting and presentation. It won't work for waterfalls, but it will

work for kids and sports of all kinds, and it will probably work best if you employ some of the techniques I've just described.

A short, snappy sequence projected quickly usually conveys action best, but the speed at which you project will depend on your subject matter. If you are showing the approach, leap, and fall of a high-jumper, you may want to cycle your photographs very quickly. If you are showing a sequence of ballet steps, you will probably want to project more slowly, so viewers can appreciate the grace of the dancer's movements.

If you're thinking of a photo sequence, be fairly liberal in your shooting and very tough in your editing. A story that can be told in ten pictures will rarely be improved if it's told in twenty. Examine your photographs carefully to determine the images and the order that convey the action most clearly and succinctly. The beauty of a sequence is that you can build to a climax; so make sure nobody falls asleep before you reach it.

# Using flash

In no other area of camera technology do improvements and variations in equipment seem to come with such rapidity as they do with flash units. The average photographer can't keep up with them, nor should he try.

The time to start thinking about what kind of flash you should buy is when you find yourself restricted because you don't have one. Before you go near a camera store, do two things. First, try to evaluate your own needs. What do you want a flash to do for you? How often are you likely to use flash? Do you ever need to illuminate large areas at night, or will a flash that lights an object up to six or seven metres away be satisfactory? Do you want a unit that measures exposure for you, or would you prefer total personal exposure control? Is the flash built into your camera all you need?

Each photographer will have to answer these questions for himself, but once you've answered them, try to find the lightest, most compact, and least expensive unit that will do the job you want.

The second thing you should do before making a purchase is to examine what other photographers are using. Ask a friend to demonstrate her equipment. Remember that anybody who has already made a purchase is likely to justify the wisdom of her choice. Be appreciative, but cautious. Next, try to make comparisons with flash units other friends own. Look for the following features: 1/ a variable position head; 2/ a wide-angle to telephoto adjustment; 3/ variable power output; 4/ capacity for manual and automatic operation; 5/ a sensor that can be connected to an extension cord for precise exposure reading; and 6/ a built-in filter holder. Now you're in a good position to ask your dealer intelligent questions.

Once you buy a flash, use it right away. Try it out in different situations. Get used to it. Don't wait until you *need* to use it before you make pictures with it. In short, start immediately to overcome any fears you may have about using it, especially if you are naturally intimidated by new equipment. What you want is another tool for effective picture control, and control comes with practice and familiarity.

With many cameras you are instructed to use a given

shutter speed when using electronic flash. While you must not use a faster shutter speed, there is nothing to prevent you from using a slower one. The flash will do its work just as effectively, and the extra exposure time will add more available light to distant areas not affected by the flash. If you do use a faster speed than what is recommended, part of your picture will be black.

Flash has application in photography both as a main light source and as a secondary one. When you use it as a main source, keep in mind what you've learned about front, side, and backlighting, all of which are forms of direct illumination. With front lighting the shadow will fall behind your subject. So, if your model is very close to a wall, the shadow may appear in the picture or it may disappear behind your subject. This can be either an asset or a liability, depending on the intended composition. If you want to eliminate a background shadow, you can move your model away from the wall or use bounce flash. With bounce flash you direct the light toward a nearby reflecting wall or object, rather than pointing it directly at your subject. The light that bounces back from the reflecting surface will be scattered or diffused, and will enable you to achieve the gentle lighting effects of a cloudy day. Read your instruction booklet to learn how to estimate exposure with your particular unit.

Flash is also important as a secondary source of illumination. You can use it to light up dark corners or objects if you want detail in these areas. The most common example is using flash to light up the face of a backlighted person whose face is darker than surrounding objects. (This is known as fill-in flash.) But, it's just as valuable when you're photographing people who are standing in bright sunlight, because their eyes are likely to be in deep shadow.

If the main source of illumination is strong, you will probably want to calculate your exposure for the entire scene, and place your flash at a distance from the object to be filled in, which will bring out its detail without making it brighter than surrounding material.

Very often you can use flash as both a primary and secondary source of illumination. One flash unit is used as the main source of light, and the second is used to fill in areas not illuminated by the first. Many portrait photographers regularly use two or more flash units, and so do photographers of botanical subjects who don't want to rely on available light. Flash overcomes movement of flowers blowing in the wind and softens harsh contrast at the same time, if one flash is used to simulate the sun and the second is positioned to fill in the dark shadows caused by the first.

If you don't have a second flash, place a piece of aluminum foil on the side of or behind the main subject (but out of the picture space). When you point your flash at your subject, the foil will reflect the light that goes past the subject and will soften strong shadows.

Of course, aluminium foil is every bit as useful for this purpose if you're not using flash at all, but want to soften shadows caused by the sun. Foil that has been crumpled and then smoothed out again is full of wrinkles. It reflects light much more evenly than unwrinkled foil, which may produce a more direct or spotlight effect. If you want to "warm" the light a little, tape in random fashion some pieces of gold foil to the aluminium. During long exposures keep moving or jiggling the reflector for even distribution of the reflected light.

Photographers who are at ease with technical data will have no trouble figuring out how to use several flash heads all at once, and indeed will take great pleasure in

the exercise. But the rest of us may find the effort neither pleasant nor conducive to good mental health. There comes a point when equipment becomes physically and emotionally cumbersome. When you reach that point, look for other solutions to your problems. Don't let your equipment stand in the way of your pleasure. The best flash equipment for you is the least you can get by with, while still making the pictures you want.

Remember that the light from a flash unit does not extend to the end of the earth. You can't illuminate a whole city or landscape with it! Similarly, there's no point in trying to use an ordinary flash unit in the fortieth row of a hockey stadium. If you capture the action successfully, it will be because of the illumination from the stadium's floodlights, not because of your flash. If you're sitting in the front row (and don't have a glass shield in front of you, which will show up the flash as a hot spot in your picture), then flash will be useful for stopping the action, provided of course that the hockey players are within range of your flash, and not at the other end of the rink. Different flash units have different power. Some will cast light over much greater distances than others. These cost more and usually weigh more. You should purchase a unit that is suited to your needs.

Flash can be useful even when you have plenty of available light and don't need it for illumination. For example, if you are photographing under fluorescent lights (which often produce unpleasant colour renditions), you can get reasonably acceptable colour by bouncing light from a flash off a white wall or ceiling, because the light of a flash closely approximates daylight. Even if you still depend on the fluorescent lights as your main light source, the flash will correct the colour to a considerable degree.

You can also use flash to create shadows that will fall across an empty area, thus reducing the visual distraction. You can use flash to illuminate one part of a picture very strongly, so other elements are subdued by comparison. You can fire off a flash during a time exposure—perhaps to illuminate a passing car at night, and then continue the exposure to record the trail of headlights and tail lights. The possibilities are endless.

However, in the vast majority of photographic situations you will not need to use flash at all. High isos with digital cameras, fast films, wide apertures, reflectors, and placing your camera on a tripod are good alternatives for photographing in low light. But, if you are buying a flash, think of it as a creative tool, as a practical aid to exposure in weak illumination, and as a device for correcting colour. If you consider its many uses, you will be more likely to select the unit which will serve you well in a variety of situations.

# Creating double and multiple exposures

Double and multiple exposures allow you to indulge in fantasy, but one of their strongest uses is the intensification of reality—making a snowy scene snowier or enhancing the weave of a meadow full of wildflowers. The photographs on pages 18 and 93 show the kind of effect you can get with multiple exposures.

Let's talk about a winter scene. Imagine the edge of a forest in a storm. Great green-black spruce trees are becoming laden with snow. Drifts are piling up around the trees, and the air is full of flakes. What you see makes you feel very "wintery," but you know the feeling won't be easy to capture on film. Try double exposure.

Set your camera on a tripod and compose your image—snowy trees and drifts that are perhaps seven to ten metres away. Focus on the trees and drifts, and shoot. (We'll explain the details later.) Then, for your second image on that same piece of film, leave the camera in exactly the same position, but refocus much closer to the camera so the nearer snowflakes seem distinct and clear. Let the background go a little out of focus. Shoot again. The result is a forest scene which seems intensely snowy. Viewers will shiver in their boots.

When spring comes, photographers flock to cherry and apple blossoms. If you're one of the people who are lured by these lovely flowers, try double or multiple exposure to express more fully the effect that they have on you. Fill the frame with branches covered with blossoms. Use maximum depth of field (f/16 or f/22) to make sure every blossom will be perfectly clear and sharp. Shoot! Then, for your second exposure, throw the entire picture out of focus in order to produce a gentle blending of pinks and whites and pale greens. Shoot again! And again several times, if you want, moving your camera a little each time. Your final image will say "It's spring!" far more effectively than a purely documentary photograph.

Is this "creating" with your camera? Maybe, but we believe it's really recording more authentically just how you feel about cherry blossoms and spring. You are capturing some of your delight.

Double or multiple exposure is a very useful camera technique that we tend to ignore or forget about, because we don't take the time to figure out how it's done. Because cameras differ it's not possible to explain how everybody can make double or multiple exposures with his or her camera, and not all digital or film cameras allow you to make them. Consult the instruction manual that came with your camera, or ask a photographer who is more experienced than you are.

Determining exposure for a multiple exposure photograph is easy, however. If, for example, you want to make eight images on top of one another, with digital capture or film, choose an ISO or film speed (let's say 100) and multiply the ISO by the number of images you intend to make (that is, eight). Then, reset the ISO to 800 and make eight images—one on top of the other. A composite image will be the result. The creative possibilities with this technique are quite endless, and we examine them fully in our companion volume, *Photo Impressionism and the Subjective Image*.

# Making pictures at night

The beginning photographer often thinks that making pictures at night is very difficult—something that only experienced professionals should try. But that's not so. If you have a tripod, or a flash, or both, you have all the equipment you need. The rest is simply a matter of learning—and the learning is easy. Making some good pictures at night will do wonders for your ego, and will give you the confidence to try photographing other situations which you regard as difficult. So plan a little excursion for evening—soon.

## Landscapes at night

In the country there's not much you can do to make a good landscape once it's pitch-black. This means that the hour between sunset and complete darkness—*even on a cloudy day*—is the time to do your shooting.

From about twenty minutes to about forty minutes after sunset, the sky and light are a deep, rich blue—if you're facing east. From about forty minutes to one hour after sunset, you'll have the same hue if you face the western sky. It's a marvellous colour, and you must be careful not to overexpose your pictures and desaturate the blue, for if you do your scene will look wishy-washy. This is particularly true when the ground is covered with snow. Your guide to begin shooting with both digital and film is when the light level gives you an exposure reading of approximately ¼ second at f/4 when you are using an ISO rating of 100.

Night landscapes in winter are usually more successful than those made at other times of the year, because the snow reflects light and shows up all sorts of detail that you can't capture in summer. However, to be successful the picture should be slightly underexposed. Also, for the best effect there should be a light source in the picture to contrast with the rich blue of twilight. Without a light in a window, or the moon, or the headlights of an approaching car, landscapes properly exposed to record the twilight colour and tones will look merely underexposed.

It may help to carry a penlight after sunset so you can read the shutter speed and lens aperture dials easily. Calculate your exposure by opening the lens as far as it

will go, say f/2.8, then read what shutter speed will give you a normal exposure, ½ second perhaps. If you want maximum depth of field for a landscape, which you often do, then choose a lens opening of f/16, for example, and make a time exposure, which would be sixteen seconds in this situation.

With film it's possible to fake a twilight scene by shooting during the daytime, using a blue filter or tungsten film, and underexposing by about two to three stops, but the effect is not quite authentic. Besides, it's difficult to come up with a contrasting spot of yellowish light that will give the dark blue cast a real twilight feeling; however, it can be done by double exposure, if you're careful. (See "Creating double and multiple exposures," page 119.) Of course, with a digital image (including a scanned film photograph) you can endeavour to make the changes you want with Photoshop. However, you will save yourself time and unnecessary effort by shooting in good conditions in the first place.

If you want to include the moon, the trick with film is to add the moon to your real or "faked" evening landscape in advance. Here's how you do it.

Start with an empty camera. 1/ Insert a roll of film in your camera and put the tip of the film leader in the take-up spool. 2/ Advance the film by hand, if you can, until the sprocket holes on both sides of the film just reach the take-up spool or some other point in the back of your camera that you won't forget. 3/ Close the back of your camera, and press the shutter release. 4/ Advance the film two more times, which means shooting off two more frames, something you do with every roll of film. Now you're ready to shoot a roll of moons, which you can use again on a future evening.

Wait until the sky is completely black, then go out with your tripod, camera, and a lens of your choosing (probably 200mm or longer). On the first five frames, with your camera in the horizontal position, place the moon in the upper right of the picture space. On the next five frames, put it in the upper left. Switch to the vertical format and repeat the right-left exercise. Continue shooting the moon until you've finished the roll. Keep exact notes of what you've done (i.e., first five frames—horizontal format, moon in upper right). Rewind the film carefully, so you don't roll the film leader inside the cassette. Put the film into the canister it came in, wrap your notes around it, and put the film in your refrigerator to keep fresh for the evening you saunter forth to make landscapes at twilight.

What you have, of course, are 20 or 36 exposures of the moon, but on each frame, only on the spot where the image of the moon was placed, is the film actually exposed. The rest of the frame is not exposed because the sky was completely black when you photographed the moon, so you can re-expose the entire film later on—adding a landscape to each moon.

When you put the roll of moons into your camera again, you must load it exactly as before if you want the moons to appear on each frame in the spot you originally placed them.

With digital capture, you can make and keep on file a variety of moon images—large or small, full or partial—and choose one to add to a night landscape image.

Remember that the face of the moon changes as you travel to different latitudes. For example, the moon is oriented very differently in South Africa and Australia than it is in Canada and Norway. So, you may also want to include latitudinal variations to your collection of moons as well.

But what about exposing the moon properly? Various suggestions will work, but try these. A full moon is quite bright, and will record perfectly by using the largest aperture at, for example, $\frac{1}{125}$ second with iso 100. (If you want some detail in the full moon, give less exposure.) A half moon is not as bright, so try $\frac{1}{30}$ second. For a crescent moon, try $\frac{1}{15}$ second. (If you breathe lightly on the lens just before you make the exposure, the moon will appear to have a soft haze around it. A uv filter will protect your lens from the moisture.)

When you're photographing only the moon, there's no reason for making long exposures, such as one second or longer, because you don't require depth of field. You don't need to use anything but your widest aperture. Besides, the longer the exposure, the greater the likelihood that the moon will move slightly during the exposure and appear to be blurred or oval in shape. This happens in exposures longer than $\frac{1}{10}$ second.

When you are calculating exposure for your landscape, don't worry about the original exposure that you gave the moon. It has no bearing whatsoever on the exposure required for your landscape. With night landscapes you should examine all parts of the picture area with even greater care than usual.

Remember that when the ground is bare, large sections may lack detail and appear murky or black in the final image, so you may want to reduce the amount of these areas in your composition.

## Night scenes in the city

Twilight is also a good time for making night images in the city, because the sky is not completely black and it's easy to see the outline of buildings. But, no matter how dark it is, you are always sure to have some artificial lighting (see photograph on page 98).

On rainy nights city pavements become an imperfect mirror of the lights above, a kind of psychedelic fantasy, and once you really start looking you'll see colour and patterns everywhere. Don't worry about the rain. Read our earlier suggestions for protecting your equipment, and head out with confidence.

When you're trying to determine what your exposure should be, meter carefully. For an average scene, avoid metering off the darkest areas or the brightest lights; instead, find an area of middle tone. If you can't avoid dark areas or bright lights, try to balance the size of the area that each occupies; in other words, strike an average and you won't be too far wrong on your exposure. While you should always try to underexpose night scenes, you can err quite a bit with city photographs and get away with it. Different exposures of the same scene simply give different effects.

If you don't want light trails from moving vehicles, wait for red lights to bring traffic to a halt. However, light trails imply activity and bustle, so you may want to make the longest time exposure you can in order to stretch or intensify the lines of moving lights. (The photograph on page 97 should be helpful.)

Long exposures are also excellent at fairgrounds, especially for Ferris wheels and fireworks. If you want several bursts of fireworks in one picture, make a time exposure. Simply place your hand over the lens when the first burst has faded, and keep it there until the next burst. Then, pull your hand away for a few seconds. You can repeat this several times without worrying about exposure, particularly if the sky is quite black. If the sky is a rich, deep blue, make sure that your lens is set at

f/16 or f/22. With these settings you can still record several bursts of fireworks without overexposing the sky.

Flash is useful at night when you want to correct the colour of objects near the lens, or if you want to prevent nearby people from being blurred. You can fire the flash as you start your time exposure, but continue the exposure to bring up detail in distant objects which the flash won't reach.

Finally, if you're afraid of prowling around the city at night by yourself, make up a small group of friends to go with you. Other photographers are best, because they won't become impatient. They'll be busy making pictures too.

### Other night situations

Learn to see darkness as a potential asset. Objects standing against a cluttered background can be illuminated by flash, which will eliminate or at least subdue the background. Night provides a dark stage curtain behind the actors and the set, and a photographer can take advantage of it to simplify design.

If you want to illuminate a background object, have an assistant stand near it with a slave unit. (A slave unit is a secondary flash that is triggered by the light of the main flash unit.) If you can't get an assistant, try a time exposure with a locking cable release. Flash your foreground as you press the release, and then, while you leave your camera in position on the tripod with the shutter open, move your flash unit to the second position and fire it again. If you feel so inclined, you can run

to several spots and fire the flash, but after a while your picture may start to get cluttered with light. Because it's dark, you can walk through your picture without showing up on the film.

Photographing lightning is rather like making pictures of fireworks. The one prerequisite is to wait until the sky is black. All you have to do then is set your camera up on a tripod, point the lens in the direction of the lightning flashes, use the smallest aperture (f/16 or f/22), and start a time exposure. Let the exposure continue until you get one good lightning flash, or two or three minor ones. It helps to have a wide-angle lens for this, because it can cover more of the sky.

If you really want to produce a winner, have a friend stand in a raincoat about three to five metres in front of the camera (once you have some lightning on the frame) and fire off a flash. The resulting shot of a bedraggled person struggling in out of the wet, with lightning flashing all around, will be a visual triumph, if not an artistic statement.

Twilight and night photography produce many technical and visual challenges. Don't shy away from photographing when it's dark just because you think the circumstances are too difficult for you. Give it a try. Start with something at which you think you may succeed, study the pictures you get, and try again. In this way you will increase the number of situations in which you can work with confidence, and before very long you'll be encouraging other photographers to join you.

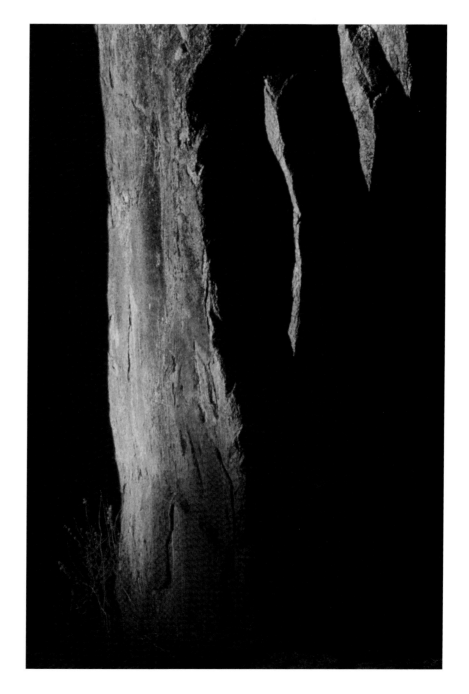

Hiking back to my vehicle at sunset, I emerged from a canyon to see the last rays of sunshine illuminating a rock with vertical bands of red light. I raced to set up my tripod, mounted my camera in the vertical position, determined exposure, and pressed the shutter release. In the ten seconds between the first photograph and the fourth (and last), the light moved up the rock and no longer illuminated the little plant at the base. The experience was a perfect reminder of why photographers should stay very familiar with their equipment, design, and exposure. (*FP*)

Zooming in or out with a zoom lens during an exposure can produce a dramatic sense of motion and create exciting design. I photographed these African dancers at $^1/_{15}$ second; my camera was on a tripod and I zoomed rapidly, commencing a split second before I released the shutter. It's useful to pre-view the subject area at the minimum and maximum focal lengths of the lens before you zoom, in order to determine what is likely to be in the final composition. However, even with repeated practice, the results will always be something of a surprise. (*FP*)

The subject matter in this photograph could scarcely be more different than in the one on the facing image, yet the design is similar. One extremely cold and windy winter day I placed a cut-glass bowl in the sunlight streaming across a table, attached a 100–300mm lens with three close-up filters on the front of it to my camera, and started exploring. I stopped two hours later when the sun disappeared, having made dozens of photographs by then. This demonstrates again that the best place to make pictures is wherever you happen to be. (*FP*)

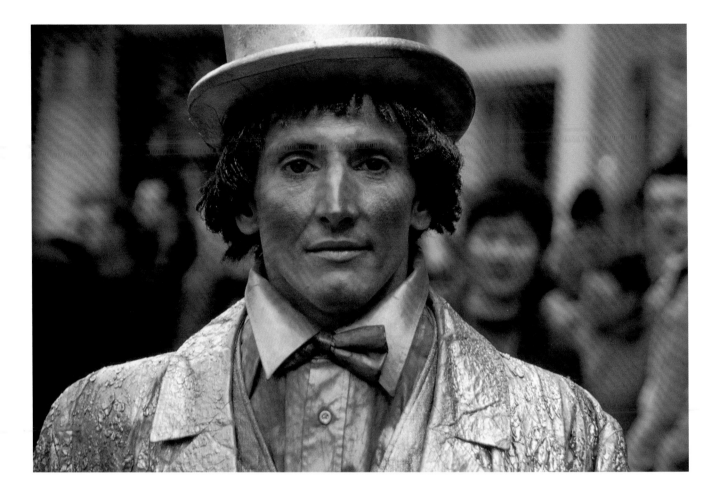

While travelling around Europe last year, I had a free day in London, England, and arranged to meet up with two good friends who are now living there. We did the tourist thing: window-shopping, sitting in cafés, and people-watching. This busker, shimmering in gold, caught my eye. I walked over, dropped a pound in his cup, and took a few photographs. To set the stage for the photograph, I made sure to include other people in the background. If you're not comfortable photographing people, try taking a picture of a street performer; it's a great way to overcome your shyness. (AG)

The best place to see and make pictures is wherever you happen to be. I was having coffee with a friend on her patio in Beirut when I noticed the shadows of chairs falling on the patio tiles. The photograph I made reminds me of that pleasant morning, and also of how important it is always to have your camera at hand so you can take advantage of unexpected opportunities. I was happy to be using film that day, as I did not need to spend the evening transferring and editing images in my hotel room. (*FP*)

Informal portraits, both posed and unposed, may include the entire body or much more of it than just the face. Don't be afraid to do unexpected things, such as cutting off the top of a person's head, if it puts emphasis where you want it. Many factors may be expressive—the position of a person's body, hands, the type of clothing, the surroundings. Soft sunlight or overcast conditions, as I had here, reduce harsh contrasts and usually make more details visible. (FP)

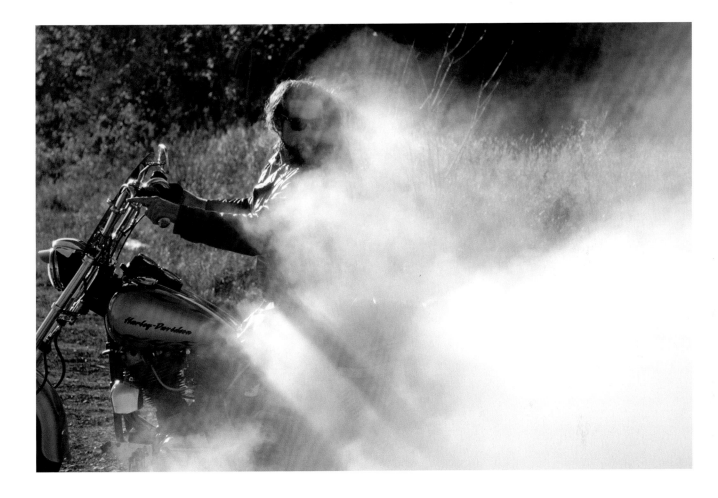

The biker here is beginning to do a "burn out," and soon gen-erated a cloud of dust that obscured him altogether. Suddenly, he zoomed out of the dust and down the highway. This image is one of more than thirty photographs that I shot rapid-fire within a couple of minutes. Using a 100–300 zoom at about mid-range, I initially positioned the bike and biker carefully in the picture space in order to fill the frame or to gain extra sur-roundings by zooming quickly in the appropriate direction. (*FP*)

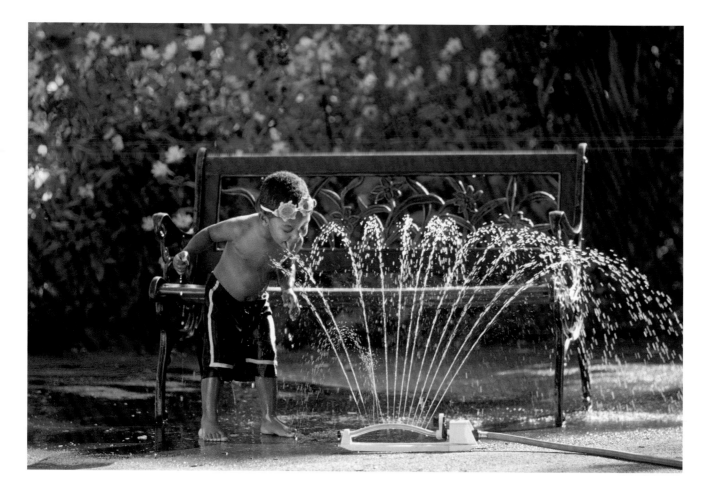

When Desmond showed up with his parents, he was very timid and would not leave his mother's side. Rather than try to photograph the boy immediately, I put the camera away and casually began talking to his parents. It did not take long for Desmond to overcome his shyness and show his true colours.

The garden sprinkler was a wonderful prop and entertained both the boy and me. The backlight makes the jets of water stand out against the shaded background. A large piece of white foam core board reflects soft light onto Desmond. The image is unposed and natural. (AG)

When I photograph children, I always bring food (fruit and colourful candy) in case of emergencies. On a cloudy but bright day, Pierre Auguste and his mother met me at a local park for a photo shoot. Rachel brought a variety of her son's clothes, including the red baseball cap and striped coveralls.

I lucked out with the food I brought—Pierre Auguste loves strawberries. Yes, the basket was once full. The clouds diffused the light, and I placed a reflector (silver side up) in front of the boy. The use of a long lens (200mm) ensured a blurred background. My only directive to the child? Enjoy! (AG)

There is only one colour in the photograph, so every detail you see is due entirely to variations in brightness or tone. I used the widest lens opening on my 100mm macro lens and focused very carefully to make the dewdrops appear very sharp, while rendering most of the picture out of focus. Early morning shade protected the poppy from strong contrasts caused by bright sunlight and also from wind movement. (*FP*)

This tulip stood out among all the others in my garden. I photographed it one morning while it was at its peak. Using my digital camera and a 180mm macro lens, I made this simple composition, isolating the bud to emphasize the delicate, dew-covered petals. Moments later, I looked at the images on my computer. If I had been displeased with the results, I could have gone back out and tried again—that's the beauty of digital photography. (AG)

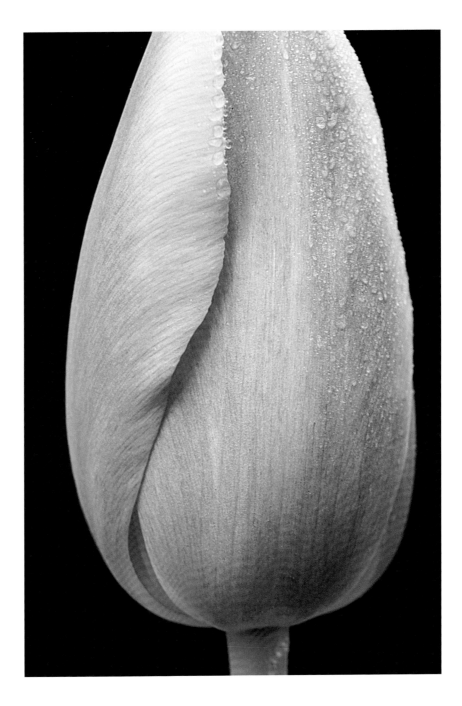

When I came across this interior scene I was reminded instantly of a Magritte painting. To capture the ambiguity I took a camera position that showed the head of the bed as a square, its solid stability contrasting with the "wild clouds" of weathered paint. At the time I made the image, the house had been abandoned for sixty years. The image is a perfect example of when a tripod is invaluable for both composition and sharpness. (*FP*)

# Photographing children and other people

Once I (Freeman) unexpectedly met a friend of mine at the Y.W.C.A. She was crawling across the floor on her hands and knees, with a camera hanging around her neck and thirty four-year-olds in tow. Everybody was having a ball! Suddenly, she stopped, turned around, and shouted, "Hey, don't we make a great snake!" By the time all the kids had stopped yelling their agreement at the top of their lungs, she had five or six pictures of them, and the snake was slithering on down the hall and into the gym.

This woman is the best photographer of children I've ever met. She always has her camera with her, so the kids never notice it. She's photographed them as giraffes, leprechauns, and trees. She's caught them plunging their hands into chocolate cake and crying over spilled milk. She's made pictures of them dressing up, talking on the phone, and having fights.

Her pictures are good because she's never forgotten what it's like to be a child. She knows how important it is to pretend, and to cry when you're sad and laugh when you're happy. Children love her. They even come in off the street and ask to have their pictures taken. If they want to dress up, she'll haul out a carton full of oversized and outlandish clothes, and let them go to it. She photographs them while they're dressing, and after they say, "I'm all ready now," they pose very deliberately, indeed.

## Photographing children

Good pictures of children are made by adults who meet kids on their own ground, but seldom by people who try it the other way around. If you start off by lining children up or by making them sit down in front of a camera, you can count yourself lucky if you get one good photograph. The images will most likely look posed and staged. So why fight the odds? Play with them, and let your picture-making be a game. The key is to have fun with children as you photograph them, and always be ready to catch their different expressions.

It's important visually to photograph children wherever they happen to be, assuming the situation is of their choosing. The local park or playground, the child's

room, or the beach is an excellent place to photograph kids. A young child will usually relate well to a favourite toy or have fun playing with a pet. As a backup plan, have some food on hand, like watermelon or strawberries, and/or some candy, lollipops, or bubble gum. Imposed circumstances are revealed by tenseness, stiffness, and apprehension in a child's face or body.

It's just about as important to toss every preconceived idea of composition out the window, and let what children are doing become your guiding principle. Don't worry about rules like "a person should be running into the picture space, not out of it," because it's common for kids to chase each other, and having a child near the edge of the picture and heading out may suggest a successful escape. Try to adopt a mental attitude that is as loose and free as that of the children you're photographing.

Usually, you will find it easier to photograph children on a cloudy bright day than in bright sunlight. You may also want to photograph when the sun is low in the sky and the light is soft. However, if you are photographing at midday when the light is strong and contrasty, perhaps you can take some action shots in the sunlight. But make portraits in a shaded area, where the child won't squint, because the light is diffused and even.

There's a good deal to be said for shooting sequences of children. Try for that one great shot, sure, but keep in mind that a series of slides or prints will probably make a more complete story, and will give added delight to the people who see them.

You'll probably be able to make sequences more easily if you depend entirely on available light, and if you keep your equipment to a minimum. Don't weigh yourself down. Select an appropriate lens, such as a 100mm or a short to medium zoom. If you are using digital capture, make sure you check your histogram once in a while. Also, remember that children will very likely get excited if you show them their picture on the LCD panel, and they will feel like they are a part of the shoot. If you are shooting with film, make sure to start off with a new roll, so you can count on a good session of shooting before you have to change rolls.

Sequences permit the use of many different techniques to convey children's activity, such as panning, blurring, and recording peak action. Sequences permit you to explore many points of view, from long-distance environmental shots to extreme close-ups. But most of all, sequential shooting encourages visual freedom and a variety of interpretations.

After you have your photographs processed, treat the children to your first projected show or exhibition of prints. Let them react to what you've done. They won't give you much in the way of visual instruction, but they will let you know by their laughter and silence which pictures mean the most to them. You won't get this sort of evaluation from anyone else, and yet it is perhaps the most useful instruction of all—kids telling adults what's good and what isn't. The children's response will help you to revise your photo story, and make you more perceptive the next time you photograph kids.

## Making candids

Most of the ideas you have for photographing children can be used when you make pictures of grown-ups, but the chances are that you'll be making more posed photographs of adults and fewer candids. The distinction between candid and posed pictures is a useful one,

because the different circumstances offer different challenges, and tend to yield very different results.

Let's consider candid pictures first. A candid photograph is one for which the subject does not prepare, although the photographer must. Good candid pictures of people don't just happen. How can you prepare? Here are some suggestions.

1  Use a zoom lens. With it you can get a variety of images with different backgrounds. It's also easier to eliminate distractions in the background by zooming in on the person and cropping for a tighter image. Hang your camera around your neck; this is one time you can forget about your tripod. An image stabilized lens is very useful in this situation, and setting the camera on shutter priority and using a shutter speed fast enough to freeze the action (around $\frac{1}{250}$th of a second) will ensure sharpness in your resulting photograph.

2  If you are using the manual mode on your camera, once you've set the shutter speed, determine which lens openings you will need for sunny situations and for shade, perhaps f/11 and f/5.6. You can do this by metering off your hand both in the shade and the sun (fill the frame with your hand). An aperture of at least f/5.6 is necessary for full-frame portraits made with a 100mm lens or longer, because it will ensure that both nose and eyes are sharp if you focus on the cheekbone. Medium depth of field gives you a margin for error in focusing, especially useful when you have to shoot fast. Establishing basic exposure settings before you make pictures means that you can shoot without worrying about changing shutter and lens-opening dials, or at most that all you will have

to do is change quickly from the one lens opening to the other.

3  Be open about your picture-making. Let people see you. That way you'll have far more opportunities than if you try to sneak around or hide. If anybody doesn't want to be photographed, he or she will either tell you or move away. Everybody else will soon ignore you. Then it's easy to shoot. If people start to pose for you when you don't want them to, waste three or four pictures. Most people, especially children, will start to relax by then, and will stop posing.

Good candid photographs of people are usually a result of good timing. You anticipate a particular moment or activity, or a configuration of elements in which a person becomes central to a strong visual design, or a significant expression or gesture—and you release the shutter at the moment when everything is right. Some photographers are especially gifted at sensing an important moment, and their photographs are records not merely of what people are doing, but of who they are and what they are feeling. It's a sensitivity that can be developed. Remember that it's the significant expression or moment that counts, so don't be unduly concerned if an extraneous element appears in a corner, or if somebody's foot is cut off.

A good exercise is to return to a situation several times, especially after you've seen the results of your first shooting. Most communities offer many opportunities to do this. Perhaps there's a senior citizens' group that meets regularly, or daily hockey practices in a nearby arena, or a busy local market. Start by photographing in situations where you feel comfortable, and

as you gain confidence you'll find it easier to photograph people with whom you are not familiar, but who intrigue, stimulate, or puzzle you. In this way photography will increase your understanding of others and will become an even greater challenge visually and emotionally.

## *Making posed pictures*

Posed photographs, unlike candids, require preparation of both the model and the photographer, and can usually be classified as either formal or informal. A formal picture of a person is one in which the model and his surroundings are strictly arranged by the photographer, often according to a preconceived design. For an informal picture, the model is given general instructions only and responds to the photographer and the surroundings with considerable freedom, while the photographer shoots. In both types of pictures the model is fully aware of the camera and is participating in the making of the picture; but in informal shooting the model creates or directs the image just as much as the photographer does. The photographer, however, chooses when to shoot, and must recognize the best moments.

The challenge of making posed pictures of either a formal or an informal nature is partly in the relationship that you establish with your subject. It's important that both of you be at ease, if you hope to make images that reveal some aspect of the model's character, personality, or mood. But outstanding posed pictures go beyond the recording of a person or persons on film, and express something universal about people. Such pictures are rare, but they are a standard to seek, because the effort will improve every picture you make.

When you pose a model for a formal close-up portrait, you are making the model's eyes the most important visual element, especially if you are shooting in black-and-white. With colour film and digital, certain hues or the intensity of colours can divert a viewer's attention to the lips or the clothes, both of which are usually of much less significance. So, you must be careful to avoid visual conflicts.

In close-up portraits it's usually best to show the dark side of the face, reducing the area that contains highlights. Try placing the brightest highlights in the eyes. A reflector is very useful in providing detail in shadows as well as creating a sparkle in the eyes (a catch light).

The placement of the model's eyes in the picture space is important. A central placement suggests rigidity. Placement above the centre of the picture area is often the best choice when you are using the vertical format, and to one side or the other when you are using the horizontal format. The direction in which the model is looking will also influence the interpretation. Downcast eyes suggest embarrassment, modesty, or sadness. Eyes that are looking up suggest anticipation, excitement, or pleasure. Seldom should both eyes of the model be on the same horizontal plane, because this reduces the sense of vitality. In order to overcome a static arrangement of the eyes, give the camera a slight tilt so the model will appear to be looking up.

You should avoid horizontal lines in a portrait in most cases, although there certainly are exceptions, and also strong vertical lines, especially if they lead to the bottom of the picture area and take your eyes out of the picture. Pay careful attention to the lines formed by the shoulders and arms. Oblique lines are dynamic lines,

and enhance the feeling of life. Usually shoulders and arms can be used to create obliques that bring a dynamic quality to the picture.

Above all, remember that lines, colours, tones, and other elements of composition are strongly influenced by the quality of light and the direction of lighting. Diffused light will establish a gentle mood and reduce contrast; strong side lighting will reveal the texture of the skin and introduce bold shadows. Try to use the elements of design and other photographic controls in ways that harmonize with the personality of your model. Since models differ, your techniques and compositions must vary.

Informal portraits are more difficult than formal ones in one respect—the photographer has less control over the model. But this lack of control has many compensations. Chief among these is the naturalness that the model shows, so the photographer needs to spend much less time and effort overcoming stiffness or nervousness. The informal approach is good for photographing people in their middle years. The very young and very old are relatively unconcerned about their appearance and status, but most adults worry about these things and are sometimes quite difficult to pose. If you can photograph them while they are talking to you or to somebody else, and thereby avoid having to pose them, you'll probably get better results.

A basic principle of portraiture, formal or informal, is to seek unity of impression between the visual elements and the model's expression. Try to determine the centre of interest before you shoot. Is it the eyes, the whole face, a certain kind of expression, or even the clothing? Beyond that, be flexible. Avoid specific formulas. The suggestions we've given you are intended as useful guides, not as rules. You must change them or ignore them when you feel your subject or the specific moment requires it.

One way to avoid stereotyped portraits is to photograph your subjects in their own environments—a truck driver leaning against the cab of his truck, a cook surrounded by shelves of spices, a woodcutter in the forest. The habitat will do more than provide information; it will add visual and psychological dimension to your pictures of people if you use it in an important way, and not as merely another prop.

There's also a reverse approach that is a lot of fun, and which can often reveal a good deal about your model. Pose your subject in a situation that most people would think of as contradictory—a nurse in a white uniform sitting on a big, black motorcycle; a leather-jacketed motorcyclist cuddling a baby; an elderly woman swinging a baseball bat. This approach is not as frivolous as it may seem. When people are placed in unfamiliar circumstances, they have to respond in terms of their past experiences, or behave in ways which they think are expected of them, or react with confusion. How they react frequently creates first-rate opportunities for making photographs.

Once I (André) was asked to photograph my partner's grandmother for her eightieth birthday. Nanny came to the house freshly coiffed and wearing a beautiful blue dress. I took the traditional portraits in my studio. When I felt satisfied with the photographs I'd taken, I still had a few frames left on the roll of film. I ran to the closet, and got one of my leather jackets and a pair of "cool" sunglasses. I noticed Nanny grinning as she put the jacket on and adjusted the sunglasses. As she gave me a big smile, I clicked the shutter. I became her

best friend that day, and that photograph of her in leather made the rounds at bingo more than a few times.

The most satisfying photographs of people usually result from close, personal feelings between the subject and the photographer. That's why mothers who know how to use a camera often make the best pictures of their children. It's also why going back to a situation again and again is so important. Repeated visits seldom exhaust the photographic potential; in fact, familiarity is essential to perception and understanding, and makes more and better pictures possible. Photographing people is one way to make good pictures—and good friends.

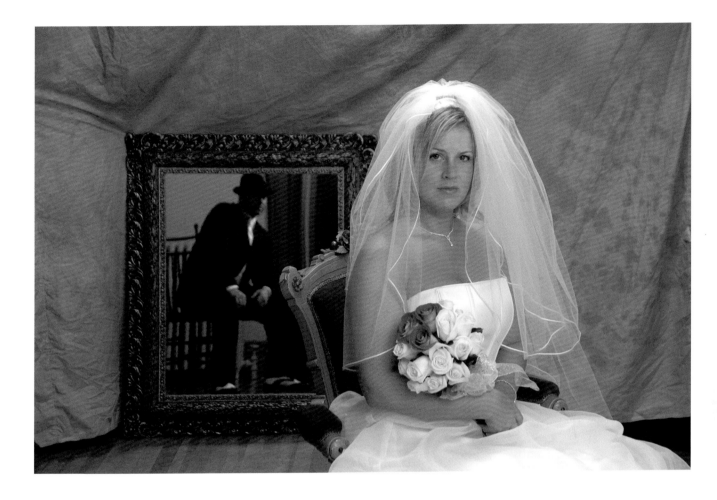

Good friends of mine were getting married, and I offered to take a formal portrait of them on their special day. When Stacey and Todd showed up at my house, I had everything ready. My living room was in the process of being painted, so the furniture had been moved out of the way. I used a bedsheet as a backdrop, creating the look of a vacant house in which the furniture is covered with sheets, and strategically placed a large mirror to reflect the groom as he looked at his new bride. By converting the digital file to black-and-white and adding a sepia tone to the image, I created the antique look I was trying to achieve. (AG)

A friend and I spent two hours photographing the autumn reflections in this pond. Every now and then a slight breeze or a falling leaf landing on the water surface would create a few ripples, providing variations in our compositions. Most of the time I focused on the surface and used a fairly wide lens open-ing. This softened the edges of the dark tree reflections, while retaining their structure as important lines. I chose film for this situation, as I could predict the excellent colour rendition, and knew that no computer work would be required later. (*FP*)

The distance between the feather and the horizon is about eight kilometres, yet everything is in focus, even the clouds. Using a 17mm lens at f/22 for this composition, I placed the camera above the feather, tilted it down sharply, and then focused about one-third of the way up the side of the picture (*not one-third of the distance into the scene*). This spot was so close I could easily reach it with my hand. The reason for focusing there is that depth of field extends twice as far behind the point of focus as in front of it, so if I focus farther away the foreground will become unsharp. (*FP*)

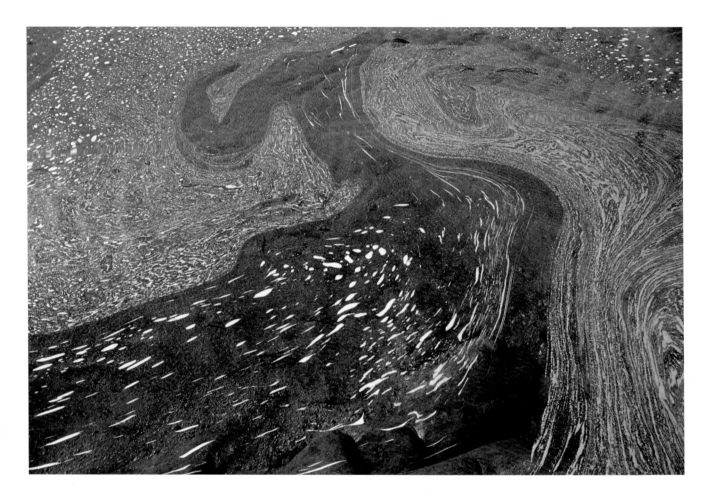

I sat on a rock beside this gentle stream most of an afternoon, watching the patterns of foam slowly moving and changing— a spontaneous ballet performed in slow motion on the water's surface. The streaking of the foam, which conveys the feeling of movement, was a natural phenomenon and was not caused by a slow shutter speed. Time seemed to be suspended that afternoon, as I experienced a gift of simple, ever-changing beauty. (*FP*)

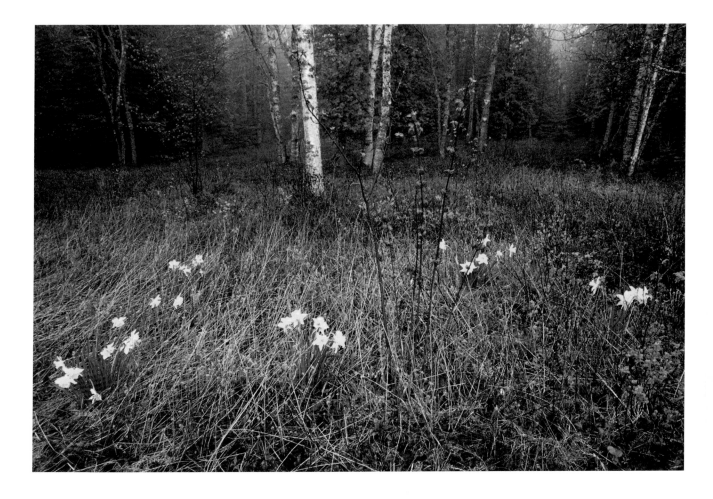

Spring is my favourite time of year, and there is nothing I enjoy more than the thousands of daffodils I've planted in the fields and woods around my house. One damp, overcast day I used my 24mm lens to record a habitat image of a few clumps. By moving in close to the nearest daffodils, standing somewhat above them while tilting my lens down almost to my toes, I was able to show the sweep of the scene. Wide-angle lenses, when used in this way, give a real sense of perspective. (*FP*)

Audrey has found herself in front of my camera many times. Whenever I come for a visit, I bring my camera along and try and capture a few precious moments of her and her brother, Richard. On this occasion, Audrey posed for me in the field behind her house, holding her favourite toy. I used a white reflector to open up the shadows on her face and add sparkle (catch light) to her eyes. Audrey, having done this a few times and knowing me well, appears casual and relaxed in front of the camera. (AG)

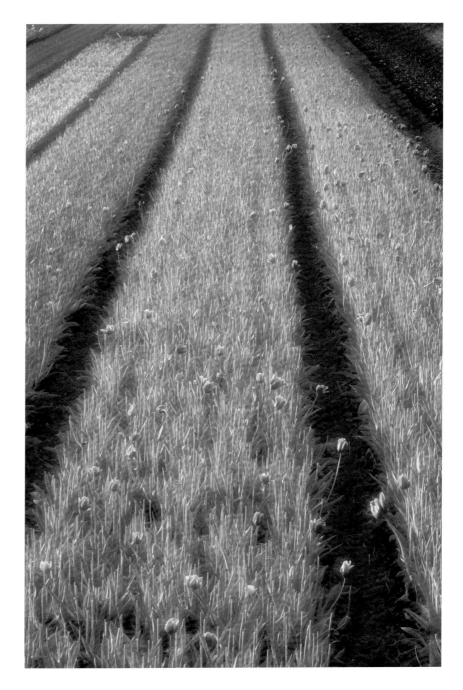

To give this image of a field of tulips in the Netherlands the feel of a painting, I chose to do a double exposure on transparency film. Placing my camera on the tripod, I first shot an image in focus at f22, underexposing by one stop. After defocusing the second image and switching my aperture to f5.6 (the widest opening), I took the second shot, again underexposing by one stop. This ensured a properly exposed photograph. (AG)

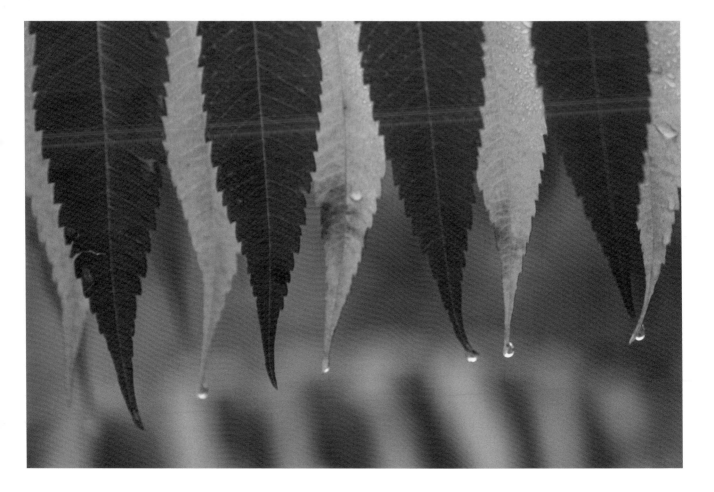

To find such beauty is to experience grace. Yet, we are sur-
rounded by beauty virtually every moment of our lives, even in
the ugliest situations. But, to see what we look at is a problem
for us all. That's why it's so important to pause, to embrace
the beauty we have, to make love with our eyes. (*FP*)

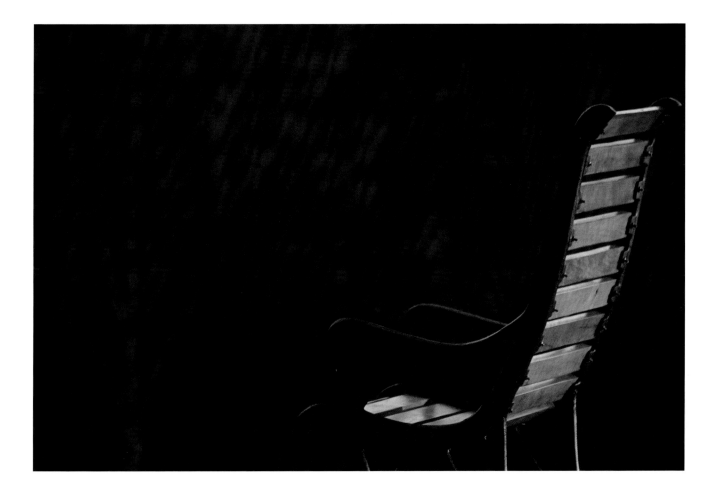

Everybody needs a special chair or two. I sit in this one a lot. Sitting there reduces my mental busyness and helps me to see—morning, afternoon, and evening—in every season of the year. From a photographic standpoint, it's one of my most valuable tools. (*FP*)

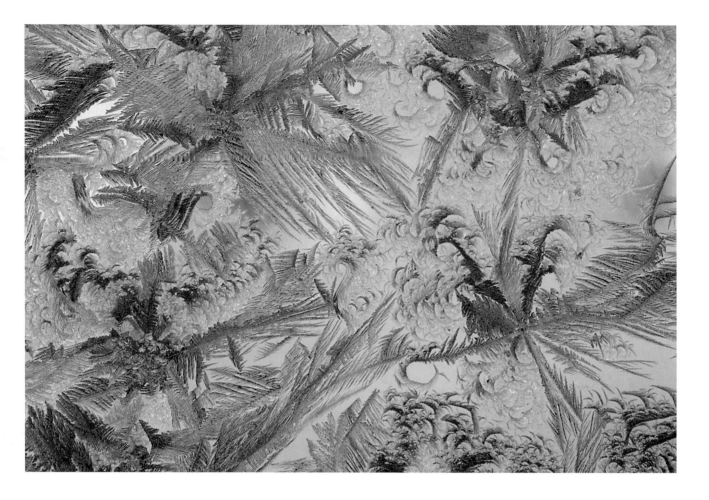

In photography, there is one advantage to extreme cold weather: the frost that forms on double-paned windows. During a cold spell that lasted a few days, I took many photographs of ice patterns, especially colourful at the first light of the day. The warm hue in this photograph comes from the light at sunrise, which contrasts effectively against the cool hues in the frost details. (AG)

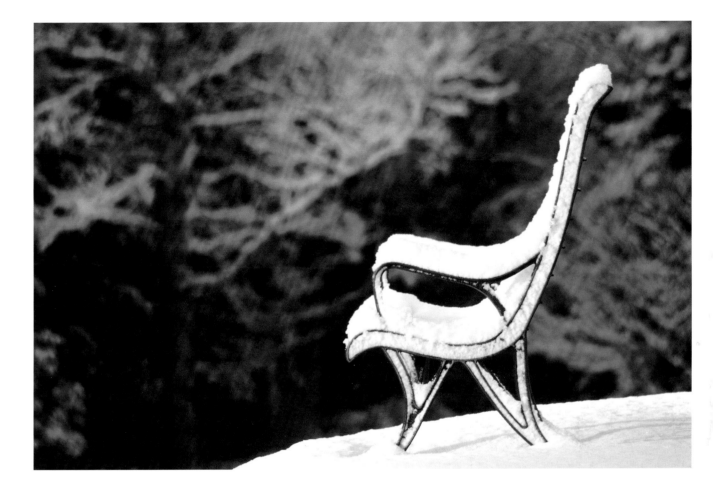

One winter morning I awoke to a world draped in white. As the sun rose in a hushed world, I watched the light gradually brightening my chair, while the background remained in shadow. When I finally finished making all the pictures of the chair that I wanted, I brushed off the snow and sat down for a while. Overnight, the view from the chair had been transformed. (*FP*)

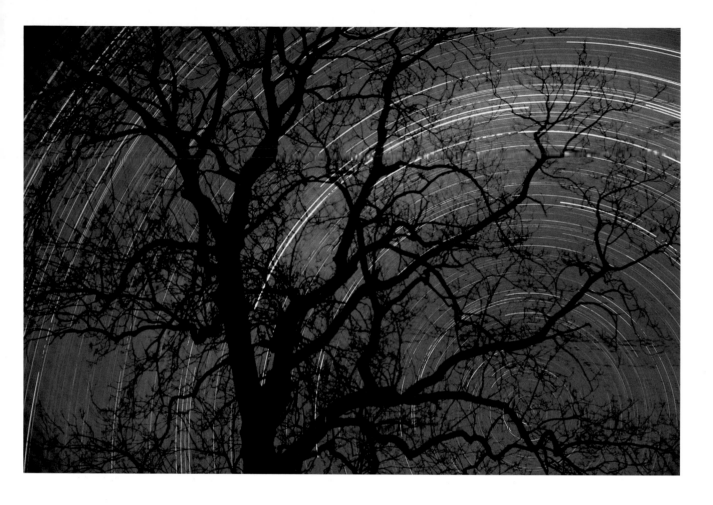

You can make a photograph like this in three ways. 1/ Set up your camera just before dark, when you can still see the horizon or other features. Open the lens to or near to its widest aperture and set it for a time exposure. When it's fully dark, press the shutter release and lock the shutter open by using a locking cable release. Go to bed for an hour or three, then get up and release the shutter. 2/ Make a night shot as described and sandwich it with a tree silhouette (or whatever works). 3/ Combine a night shot with another image in Photoshop. (*FP*)

154

# Forty tips and suggestions

Over the years you will read or hear about various tips that will not only help you make the images you want, but also guide you in the use of your photographs, both personally and commercially. Keep a record of these. They can be very useful. Here are some I have found worth recording.

1   If you are in doubt about the order of the steps to follow when making a photograph, keep the letters C, D, E in mind—in their alphabetical order. C = composition, D = depth of field, E = exposure. More often than not, you should attend to things in this order.

2   If you are making pictures on a bright, sunny day, but your light meter is not working, here's how to determine the shutter speed and aperture to use. Set your lens opening at f/16; for front and side lighting the shutter speed will always be similar to your ISO rating. For example, if your are using ISO 100 and the sun is shining, your shutter speed will be ¹/₁₂₅ at f/16; with ISO 200, your shutter speed will be ¹/₂₅₀ second at f/16. If you don't want to use that shutter speed, you can change it, but you will know the proper combination of shutter speed and aperture.

3   If you have a fast film in your camera, and the light is so bright that you can't close down your lens as far as you want, *you can* use your polarizing filter or a neutral density filter to reduce the amount of light reaching the film.

4   If you are using film and discover, halfway through the roll, that you have been using the wrong ISO rating, don't correct your mistake. Finish the entire roll at the wrong ISO. Then, when you take the film to the laboratory for processing, tell them about your error. They can compensate in the processing and save the film. This applies to both black-and-white and colour films. If you change from the wrong ISO to the correct one part way through the roll, you will sacrifice all the pictures you made before you made the correction.

5   If you find yourself fussing over pictures, or simply spending far too much time finding something you

want to photograph, set yourself an assignment. Give yourself exactly five minutes to make five different images. Then speed it up; give yourself five minutes to make ten. You can choose a specific subject in advance, if you want, such as ten abstracts, or ten shots of a particular meadow. This exercise is a remarkably good way to zero in on the essentials of making a picture.

6 If you find that you are always photographing the same subject from the same point of view, deliberately set yourself the assignment of looking at the subject in different ways. For example, instead of trying to obtain lighting and detail in all parts of a person's face when shooting a portrait, try a series in which the person's face is illuminated entirely from one side. Or, instead of looking at a spider's web only from the front, try looking at it from the side. Or, photograph your yard from the level of your dog's eyes.

7 Try montages with both film and digital. It's easy to sandwich two slides together by removing both of them from their mounts and putting them together in a single mount, and it's easy to do with digital images as well.

In Photoshop, open up both images at the same size. Drag one image over the other, then go to the Layer box and click "multiply." Your two images will merge into one composite photograph. If your final image appears too dark, you can adjust your exposure once the image has been flattened, or you can get a different effect by adjusting each individual photograph separately. You can do this by undoing "multiply" and selecting the layer you want to adjust (or both of them perhaps). Then go to Image (at the top of the screen), click on Adjustments, and lighten (or darken) by using the levels. When you're happy with the result, go to the Layer box and flatten the image.

Photographers have been making montages for years to add sunsets to dull scenes or a bird to an empty sky. However, there are many unexplored possibilities for sandwiching, especially in the field of colour abstracts. Start experimenting with slightly overexposed images that are not related in subject matter, but may make interesting colour and design combinations. With the ideas you get, you can begin shooting pictures deliberately for sandwiching. Overexposed textures can add a wonderful painterly quality when combined with other images, like flowers, trees, silhouettes, etc. Your purpose will be to make composite photographs that are compelling images when they are shown as one picture.

8 Many photographers look for reflections of colours in calm lakes and ponds; but look in moving water too. You won't find definable shapes, but you will find streaks and masses of flowing colour. Usually, the lower your camera position is the more likely you are to pick up these colours.

9 One of the very best ways to improve your ability to make good compositions is to disregard the subject matter and its meaning, and to look at your material purely as graphic design. Pay special attention to the size, placement, and brightness of every tone in the picture space, whether you are shooting black-and-white or colour.

10 Christmas lights can create marvellous effects. By moving in close and throwing foreground lights out

of focus, you will get overlapping circles of colour, which add mystery and merriment to Christmas scenes. If you breathe lightly on your lens or filter before releasing the shutter, you will produce an aura or glow around each light. In most cameras you can see the effect through your viewfinder and make the exposure immediately or as the mist on the lens starts to evaporate. Also, try double exposures and montages with holiday lights.

11 Fill-in flash is as useful on a bright, winter day as it is at any other time. For example, you can use it to show detail in dark objects that you are photographing against the sun. The snow may act as a reflector and bounce light into shadow areas, but if it doesn't, and you are confronted with very strong contrast, use your flash.

12 When you are making a portrait and need some light reflected on your model's face, give the subject a newspaper, a piece of kitchen foil, or white paper to hold as if reading it. This may provide the light you require. Ideally, the paper should not appear in your picture.

13 Putting a white handkerchief over a flash diffuses and reduces the illumination. One layer reduces light by one f/stop, two layers by two f/stops. You can hold the handkerchief on with an elastic band.

14 If you are photographing in a room that is lighted entirely by tungsten or fluorescent bulbs, and you do not have the proper films or filters available to correct the colour rendition, consider overexposing your film slightly. This will desaturate the colours, and make unpleasant colour effects less pronounced. This situation is not a problem when you are shooting digitally, as you can correct colour rendition using the white balance function on your camera, or colour correct using Photoshop.

15 When shooting through glass, you can avoid reflections if you fit your lens with a flexible rubber lens hood. By placing the hood against the glass, you will eliminate annoying highlights and unwanted colours reflected in the window. If you do this with long telephoto lenses, take care to have the lens perpendicular to the glass, or distortion may occur.

16 When making nature close-ups, the easiest way to remove small distracting objects is to cover them up with material indigenous to the area. For example, if a small piece of distracting white birch bark is wedged among fallen brown leaves, simply use another leaf to cover it. Keep your picture authentic; don't cover the birch bark with a fern frond, just because you like ferns.

17 Sometimes it is virtually impossible to photograph a flower that droops or hangs down, such as a bluebell or a pitcher plant, especially the centre of the flower. To overcome the problem, try using a mirror. Place the mirror on the ground underneath the flower, and shoot into the mirror. The blossom will probably have the sky as a background. If the centre of the flower is too dark, you can use a reflector to bounce light into the centre of the flower, and still shoot your picture by aiming your camera at the mirror.

18 You can usually photograph moving objects that are fastened at one end, such as a waving fern, at slower shutter speeds than unattached objects moving at the same speed.

19 When hunting wild animals with a camera, there is usually little point in trying to stay hidden. Allow the animals to see you, as you move slowly, cautiously,

and indirectly toward them. Always avoid swift or jerky movements. If you have enough patience, you may even be able to walk among them in the end. When camouflage is essential, wear patterned clothing, not solid colours. Some animals are attracted by unusual actions, because their curiosity is aroused. Allowing a white handkerchief to flutter in the breeze has been known to attract deer and pronghorn, for example. Other animals are curious about humans crawling around on their hands and knees. (Don't try this with lions.)

20 It makes sense to have two camera bodies—for several reasons. (Be sure your lenses will fit both cameras.) With digital, having two bodies fitted with two different focal length (zoom) lenses means you won't have to switch lenses as often, and less dust will get to the sensors. With film, two bodies will also allow you to shoot colour and black-and-white film at the same time, or a fast and a slow film. Two bodies also means less switching of lenses. And, a second body means that you won't have to suspend your photographic activities when one is being repaired or serviced.

21 If you want to reduce the possibility of your photographic equipment being stolen, use an inconspicuous camera bag, such as a flight bag. Also, don't put decals of photographic societies on your camera bag or car window.

22 To keep rain or snow off your camera, put it in a plastic bag that has a hole cut out for the lens or use a shower cap.

23 Lightweight plastic or Gore-tex rain pants are excellent photographic gear for rainy days, and mornings when the grass is wet, as they make kneeling in the grass easier than using a rubber or plastic sheet, which is often a bother to carry around. Gardening or rollerblading knee pads will prevent discomfort when photographing on your knees.

24 If you travel in a car that has separate or bucket seats, you can secure your camera or camera bag against bumps or falls by looping the strap around the back of the seat.

25 An easy way to carry extra lenses on a hike is to put them in their cases and loop them onto your belt. Filters, extra rolls of film, snacks, etc. can be carried in an empty lens case in the same way.

26 If you keep losing cable releases, tie a red ribbon on your new one. When you misplace it, at least it will be easier to find. However, why not tie a string around the middle of your cable release and tie the other end of the string to your tripod? If your cable release comes unscrewed from the camera, you won't lose it.

27 Every original artistic work is automatically protected by copyright from the moment of its creation. Original artistic works include photographs. Thus, no formalities are necessary to copyright a photograph in Canada, and this copyright is automatically valid in most countries. To be protected after publication, you must place a copyright symbol, the year, and your name on all copies available to the public. In Canada, protection for photographs by copyright is for fifty years from the moment the photograph is published.

28 The owner of the copyright for a photograph is the person who owns the original negative, transparency, or digital file. Usually this is the photographer. However, photographs made on assignment or

commission belong to the person or firm granting the assignment, unless otherwise specified in writing. For example, if somebody commissions you to make his portrait and agrees to purchase it on completion, the copyright does not belong to you, but to the person who commissioned you, even if you retain possession of the original files or negatives.

29 When you sell a photograph, you do *not* sell the copyright. The only way you can transfer copyright is by a statement in writing. You can assign (transfer) copyright in whole or in part, subject to any restrictions you want. It's very important to be specific in assigning copyright. You can specify a stated period of time, a given geographical area, a particular medium or vehicle of reproduction. (For example, one-time reproduction rights to two photographs of grain elevators at Minnedosa, Manitoba; to be published in the annual calendar of Western Grain Growers; the year; for distribution in Manitoba, Saskatchewan, and Alberta only.) You can be less specific and assign the buyer all North American rights, or all Canadian rights for a certain period of time, or simply all rights. The greater the rights you sell, the higher your selling price should be.

30 If you intend to have a photograph published, consider whether or not you need a model release from the people who are in the photograph. As a general rule, you may photograph a street or other public area or anything without gaining permission from people in the picture. However, if one or just a few people are singled out, written permission must be granted by the individual(s) if your photograph is to be used in advertising matter—unless the person is a celebrity and has, as a result, surrendered that part

of his right to privacy. If the photograph is used as a matter of public interest, as in a newspaper, and concerns something the public has a right to be informed about and is used in just that way, the public's right takes precedence over that of the individual. Remember, though, that the law defends everyone against defamation. If a photograph defames a person's character, either through the image itself or in the way it is used by a publisher or advertiser, the photographer may be liable along with all others involved. A photograph that represents bare comment or illustrates a proven fact cannot be called defamation.

The same applies to someone's house and possessions. Unless it's editorial content, you need a "property release" if you intend to sell an image where you can recognize a property, a house, or a boat, for example. Also, be cautious of brand names and logos. A bunch of logos is acceptable, but a single or prominent one may cause you some trouble.

31 Try photographing concepts—joy, anger, restraint—as colour abstracts.

32 Try photographing with nylon stockings over your lens, or take a clear filter (uv or skylight) and coat it lightly with hairspray from an aerosol can. This will diffuse light and add a painterly quality to your images.

33 If you have Photoshop or a similar program, spend an hour a week trying different tools and filters. By doing this, you'll familiarize yourself with new functions, and get to know the program and your computer better.

34 A good exercise is to make photographs of common things found around your house or apartment

(anything from a lemon to a bathroom sink to reflections in an aluminium cooking pot), and make three to five different compositions of each. If you belong to a camera club or have some friends you photograph with, encourage them to participate in this exercise. Afterward, you can get together with them to view and discuss the results. (A variation on this is to choose three common objects at random—some cooked or uncooked spaghetti, a comb, and a book—and try combining them as a still life.)

35 Stand in one spot with a camera and a telephoto zoom lens (let's say 100–300mm) on your tripod. Make twenty good compositions without moving the tripod, only the camera on top of the tripod. Then take a randomly-chosen number of steps in any direction, and repeat the exercise. Your seeing will improve—fast!

36 Another exercise to try is to make ten digital or film images per day for a specific amount of time. You can try this on the weekends if your workweek does not allow you time during the week, but increase the number of images to thirty or thirty-six. This will keep your seeing fresh.

37 Have a photographer friend join you in writing the name of an object, a situation, a concept, or an idea on ten or fifteen individual slips of paper. Put them all in a bowl. Then, once a week, draw out a slip for each person. What's written on the slip is that person's photo assignment for the week. This is a great shared project for friends, especially if you get together to view the results.

38 Choose something you dislike—a pile of junk in the corner of a porch or a heap of dirty laundry—and make an assignment of photographing it well.

39 Trade images (and assignments) by email on a regular basis with a photographer in a country very far away or different from your own. This can be an extremely educational project, especially if you can also write to each other about your images and your lives. Some photographers have formed international photographic circuits (which are less personal) for discussing pictures.

40 Membership in camera clubs, photographic societies, and national photographic organizations, such as the Canadian Association for Photographic Art (CAPA), the North American Nature Photography Association (NANPA), and the Photographic Society of America (PSA), can be valuable. Many other countries also have one or more national photographic societies or associations. Usually, the small membership fee will be quickly paid back by what you learn.

# About FREEMAN PATTERSON

FREEMAN PATTERSON'S interest in photography began in childhood, even though he was twenty before he could afford his first camera.

Freeman was born at Long Reach, New Brunswick, graduated with a B.A. in philosophy from Acadia University in Nova Scotia, and received a master's degree in divinity from Union Theological Seminary at Columbia University in New York. The title of his master's thesis was "Still Photography as a Medium of Religious Expression." During his three years in New York, he studied photography and visual design with Dr. Helen Manzer.

After teaching religious studies for three years at Alberta College in Edmonton, Freeman resigned his teaching position to devote himself full time to photography. Since 1965 his photographs have been published in numerous books, magazines, journals, newspapers, and advertisements, and have been exhibited around the world. Many of his photographs were selected for the National Film Board's three award-winning books, *Canada: A Year of the Land*, *Canada*, and *Between Friends/Entre Amis*. He is the author of other acclaimed books: *Photography and the Art of Seeing*, *Photography of Natural Things*, *Photographing the World around You*, *Photo Impressionism and the Subjective Image* (co-authored with André Gallant), *Namaqualand: Garden of the Gods*, *Portraits of Earth*, *The Last Wilderness* (writer and photo editor), *ShadowLight*, *Odysseys*, and photographer for *In a Canadian Garden*.

Among the many awards and honours Patterson has received are the gold medal for distinguished

contribution to photography from Canada's National Association for Photographic Art, the gold medal for photographic excellence from the National Film Board of Canada, the highest award (Hon EFIAP) of the Fédération Internationale de l'Art Photographique (Berne, Switzerland), the Lifetime Achievement Award of the North American Nature Photography Association, and two honourary doctorates. He has been elected a member of the Royal Canadian Academy of Art, a fellow of the Photographic Society of America, and an Honourary Fellow of both the Photographic Society of Southern Africa and the Nature Photography Society of New Zealand. In 1985 he was awarded the Order of Canada.

From his home at Shamper's Bluff in rural New Brunswick, Patterson travels and lectures frequently in Canada, South Africa, and other countries, sponsored by photographic, environmental, and educational groups and institutions.

For more information on Freeman Patterson and his work, please visit www.freemanpatterson.com.

# About ANDRÉ GALLANT

ANDRÉ GALLANT is a professional photographer based in Saint John, New Brunswick, who specializes in travel photography and works around the world.

He is the co-author of *Photo Impressionism and the Subjective Image* and author of *Photographing People: At Home and Around the World*, the fifth and sixth volumes in the instructional series started by Freeman Patterson; *Destinations: A Photographer's Journey*; *Dreamscapes: Exploring Photo Montages*; and was the photographer for the illustrated books *Winter*, *The Great Lakes*, and *Seacoasts*, all written by Pierre Berton. In 1996 he joined Freeman Patterson as a teaching partner in his visual design workshops at Shamper's Bluff, and together they teach several week-long workshops in photography and visual design in their native New Brunswick. He also lectures regularly across North America, and from time to time in New Zealand, the United Kingdom, and other countries.

He is a regular contributor to *Photo Life*, and his work has been published in *Canadian Living*, *Canadian Gardening*, *Canadian Geographic*, *Doctor's Review*, *Elm Street*, *Fleurs, Plantes et Jardin*, *Gardening Life*, *enRoute*, *Our Canada*, *Outdoor Photographer*, *Today's Parent,* and *Vous*. He is the recipient of several National Magazine Awards.

His commercial clients include Kodak, Tourism New Brunswick, the City of Saint John, Graphique de France, and Unicef, to name a few. His work is licensed worldwide through Getty Images, Iconica, and First Light.

For more information on André Gallant and his work, please visit www.andregallant.com.